HEBBURN
THROUGH TIME
Derek Dodds

AMBERLEY PUBLISHING

Acknowledgements

Norman Dunn and Kevin Blair contributed much to this compilation. Both provided invaluable information and photographs, and Norman allowed me to reproduce images from his 'Old Hebburn, Jarrow and South Shields' website. This features the work of local photographers, too numerous to name here, but all of whom I gratefully acknowledge. I am indebted also to John Diamond, whose painstaking 'Hebburn Records' are an indispensible reference source and to John Hayton, whose postcard of Ellison Hall started the project off. Other important contributors were Arthur and Thelma Pattison, Jessie Mogie and Alec McDonald (members of Jarrow and Hebburn Local History Society), Ron French, Alan Wright of the Reyrolle Heritage Trust, Colin Mountford and the local studies staff at Newcastle and South Shields Libraries. Many thanks also to June and Andrew Dodds and finally to all Hebburn people, past and present, to whom this book really belongs.

First published 2013

Amberley Publishing
The Hill, Stroud
Gloucestershire, GL5 4EP

www.amberley-books.com

Copyright © Derek Dodds, 2013

The right of Derek Dodds to be identified as the
Author of this work has been asserted in accordance
with the Copyrights, Designs and Patents Act 1988.

ISBN 978 1 4456 0810 5

British Library Cataloguing in Publication Data.
A catalogue record for this book is available from
the British Library.

Typeset in 9.5pt on 12pt Celeste.
Typesetting by Amberley Publishing.
Printed in the UK.

Introduction

Hebburn on Tyne has been transformed since its origins in Anglo Saxon times. From a tiny eighth-century fishing hamlet it has grown into a modern town covering approximately 3 square miles with a population of around 20,000. Until the Dissolution of the Monasteries, much of this riverside area was in ecclesiastical hands, but in the mid-seventeenth century the ambitious Ellison family began to make their local mark. Robert Ellison, a wealthy Newcastle merchant, acquired Hebburn Manor, and by 1800 an impressively enlarged Hebburn Hall – still the town's most historic structure – dominated the surrounding landscape.

Because royalties from coal extraction and the dumping of ships' ballast were a significant part of their income, the Ellisons were well-placed to benefit from the birth of industry in the early town. By 1786, Hebburn Quay was an established 'ballast shore', and six years later large-scale mining operations commenced just to the south-east of the quay, from the first of a series of pits that went on to produce high-quality coal for over a century.

Terraced squares of cottages were built near the pithead in the colliery district, and when shipbuilder Andrew Leslie arrived at Hebburn Quay from Aberdeen in 1853 the town's pace of expansion quickened considerably. Although the quay was formerly used for minor repairs to vessels, Leslie was soon recruiting men from Scotland and Ireland to keep pace with orders for his blossoming enterprise, and workers' houses were erected on the riverbank that led to his new shipyard. This was a time of rapid economic growth on Victorian Tyneside, which greatly benefited the young town of Hebburn.

Eager to repeat Leslie's success, other manufacturers were attracted to Hebburn, establishing brick, metal and small chemical works in an increasingly busy quayside area. They were joined by the much larger operations of Tennant's alkali works and the Tharsis Sulphur & Copper Company, both of which attracted labour to Hebburn from across the British Isles.

More accommodation for this extra population influx was provided adjacent to the new public railway line, which opened in 1872. Hebburn Newtown had begun to take shape and in 1894 the three districts of the maturing township were recognised as an independent Urban District, with Scotsman Thomas Braid appointed as first Council Chairman. During this period much of what was once described to 'stand sweetly in the plain' was disappearing beneath the familiar grid pattern of Hebburn's streets, schools and churches.

As the twentieth century progressed, heavy engineering and (to a limited extent) coal mining continued to be a major source of the town's employment. But modern industries also began to supplement them, in particular the electrical switchgear company founded at the Newtown by Frenchman Alphonse Reyrolle in 1901. They were to prove vital through the hard times to come.

Of course, like most of its Tyneside neighbours, Hebburn was not immune to frequent economic slumps. On visiting Hebburn in the depths of the 1930s depression, writer J. B. Priestley was appalled by the unemployment and poverty on view. Yet he also commented on the spirited efforts of Hebburn townspeople to encourage self-help and improvement.

Near full employment was established during the Second World War, and post-war prosperity brought slum clearance and renewed expansion to the town. Hebburn's appearance was changing once more. Its confidence was expressed by the creation of a new civic centre in 1967. But further blows were dealt by a subsequent decline of industry and the steady loss of prominent local businesses.

Nevertheless, even in today's new age of austerity, the town has attempted to progress. While they can never provide enough jobs, light industrial and commercial units have replaced many dimly remembered streets. Similarly, despite slow-moving plans for a new shopping centre, an ambitious school-building programme approaches completion and attractive housing developments now stand on former factory sites. As may hopefully be appreciated from the photographic journey that follows, Hebburn is a small town with a big history. Its people should take pride in their past and have hope for their future.

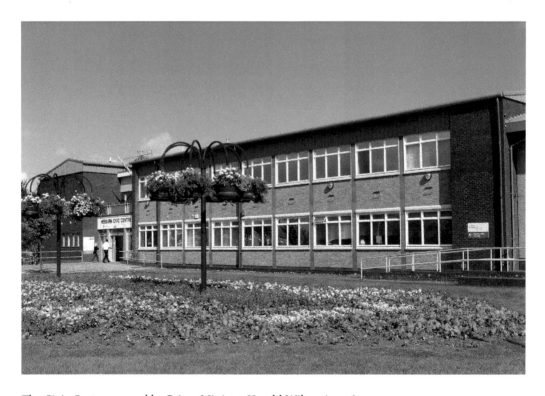

The Civic Centre, opened by Prime Minister Harold Wilson in 1967.

Byron Avenue
Decorative railings in Byron Avenue.

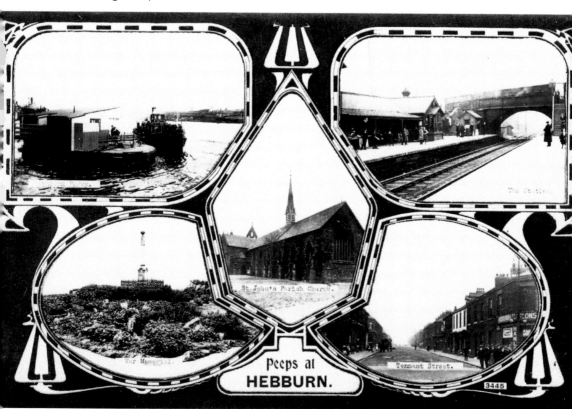

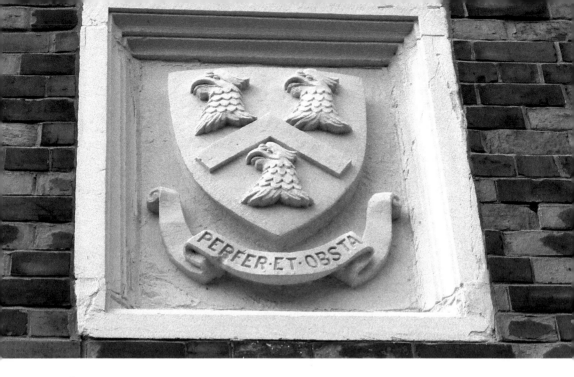

Coat of Arms
The Ellison coat of arms. The motto *Perfer Et Obsta* loosely translates as 'endure and oppose'.

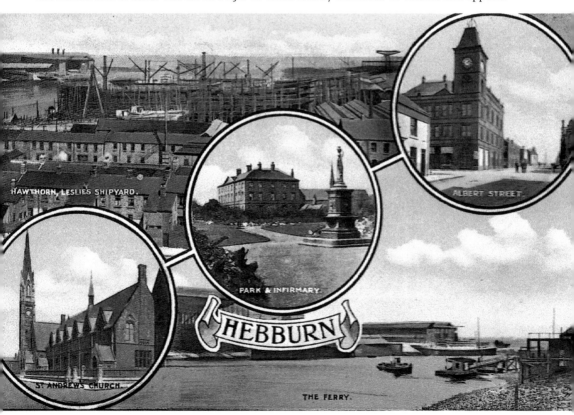

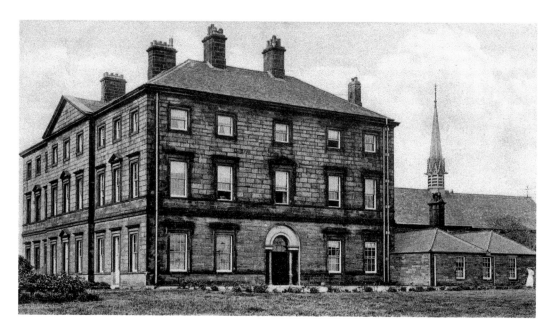

Hebburn Hall, *c. 1910*

Rebuilt on much older foundations around 1790 for Henry Ellison, Hebburn Hall was vacated by his son Cuthbert for healthier climates in the 1830s. Afterwards the impressive mansion had various tenants, most notably Sir Herbert Rowell, director of Hawthorn Leslie's shipyard. In 1898 the hall became the town's infirmary and more recently was used as a social club until, after years of neglect, the building was rescued by local developers who have restored it to luxury accommodation again.

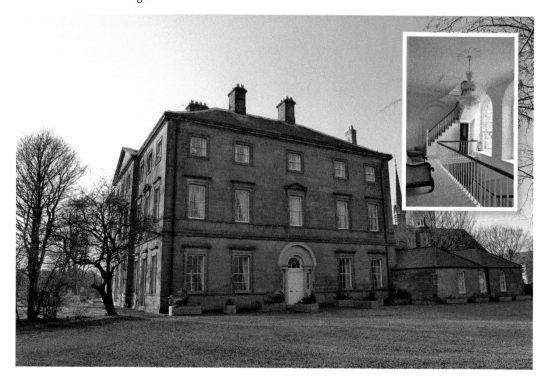

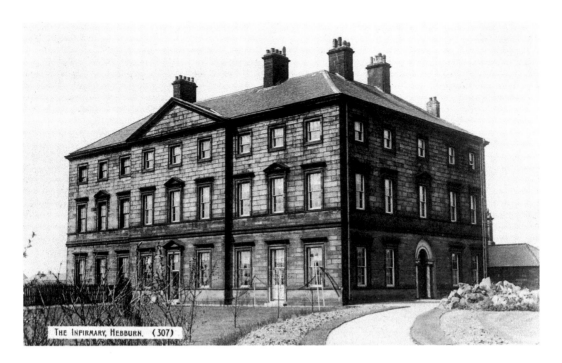

THE INFIRMARY, HEBBURN. (307)

Hebburn Hall (Ellison Hall), *c.* 1905

Hebburn Hall has changed greatly over the centuries. Originally a medieval tower, it became an Elizabethan mansion before the Ellison family transformed it to one of the area's finest classically styled buildings. Newcastle architect William Newton is believed to have designed the present Hebburn Hall. Within thirty years it was superficially altered, this time by John Dobson. Two centuries on – despite the screen of trees – the grandeur of the hall's south front remains plain to see.

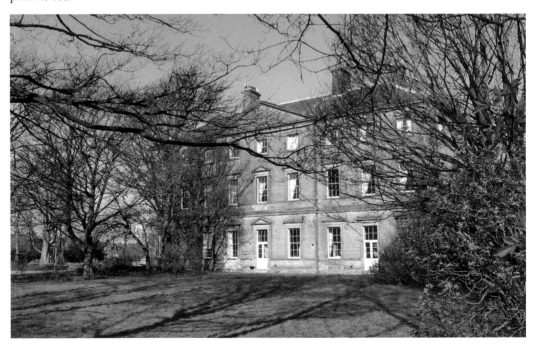

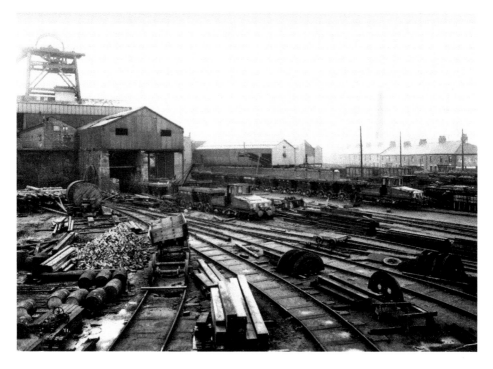

Hebburn Colliery 'A' Pit, 1922

At more than 700 feet, 'A' pit was Hebburn's first deep coal mine. Heavy flooding was encountered during its sinking in the 1790s and gas remained a constant danger – explosions in 1805 and 1849 killed a total of sixty-nine men and boys. By 1900, around 1,300 colliers were employed but in 1931 the financial collapse of the Wallsend & Hebburn Coal Company effectively ended mining in Hebburn. 'A' pit is now covered by the 1990s Walsh Avenue estate.

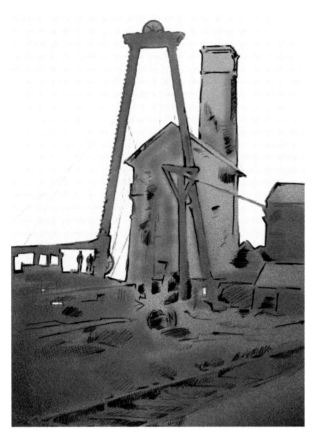

'B' Pit – Black Road, *c.* 1900
Colliery owner Mr Wade opened
'B' pit around 1800 and it was
subsequently used to pump water
from surrounding workings. In
1815 Humphrey Davy's safety
lamp was tested in the mine but
financial and geological problems
ended production before 1900.
Houses on Black Road were built
around the filled-in shaft in the
1930s, leaving only a few stones
in a back garden from 'B' pit's
Boulton & Watt engine house to
mark the spot.

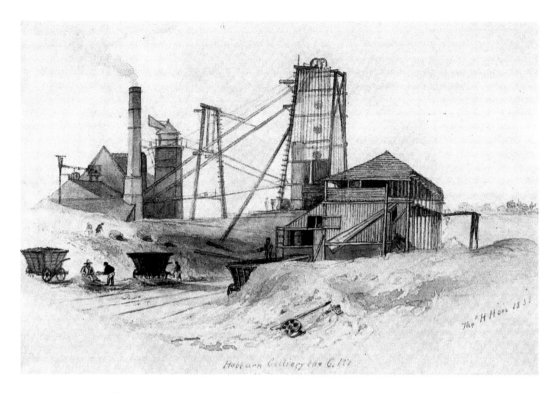

Hebburn Colliery 'C' Pit, 1838

Hebburn's 'C' pit was sunk at the end of the eighteenth century on the riverside slope where houses are today at the top of Ellison Street. Thomas Hair's painting shows the colliery at full swing with the pit shaft and its head gear in the centre and a smoking engine chimney and vaned ventilator on the left. Coal is being shovelled into wagons or 'chaldrons' and what may be a wagonway appears indistinctly in the foreground.

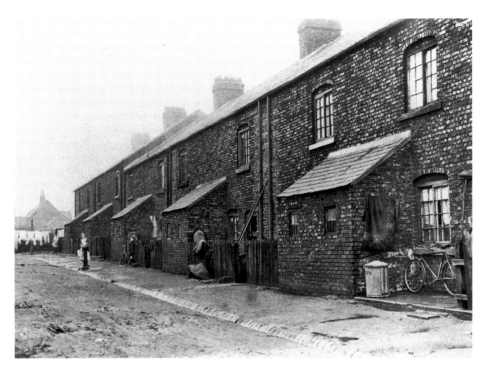

Chapel Row Back Lane, Hebburn Colliery 'A' Pit, c. 1900

Chapel Row was part of an area called the Square, built near the pithead. The row's dozen houses appear to have been better than the average pit village accommodation. Although lacking ventilation, their two rooms were thought to be acceptable by Durham's medical officer. However, his 1888 report goes on to condemn adjacent rented property as 'grossly insanitary'. That could never be said of the neat properties of Brancepeth and Auckland Roads, which now sit comfortably on this historic site.

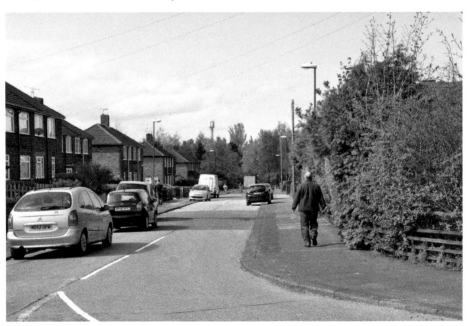

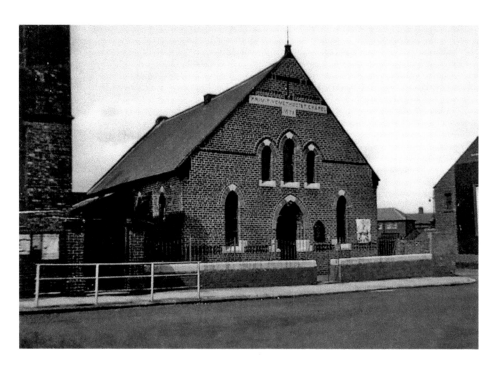

Methodist Chapel, High Lane Row, c. 1960

Methodism was first established at Hebburn Colliery in 1823. Preacher John Branfoot held services in fields and pit cottages but it was another twenty years before the first Primitive Methodist chapel opened on Chapel Row. Paid for by mine owner James Easton it was followed by two others over the next half-century. The High Lane building featured here (Colliery Board School above on the left) was founded in 1875. Today a Jehovah's Witness meeting place, it rejoices in the name Kingdom Hall.

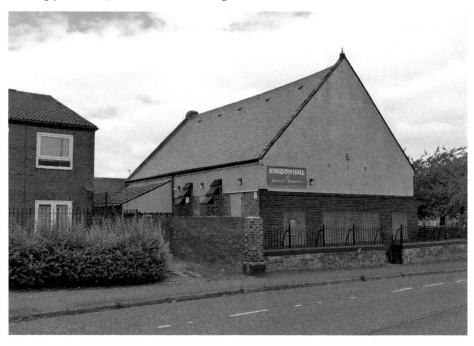

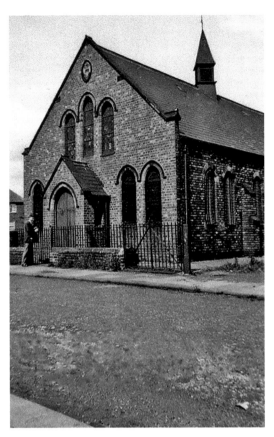

School Street Methodist Chapel, *c.* 1960
Formation of the United Methodist Free Churches in 1857 led to the building of another chapel in Hebburn Colliery. The School Street building was founded in 1877, and though the chapel escaped German bombing of the area during both world wars, the pit's closure and a shrinking congregation eventually forced it to close. Used as a day centre before demolition in 2002, its site is now increasingly difficult to locate in the surrounding £3 million new housing scheme.

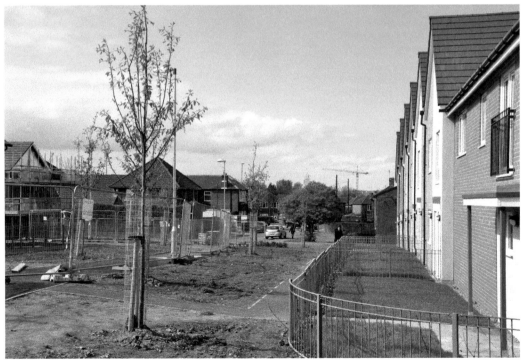

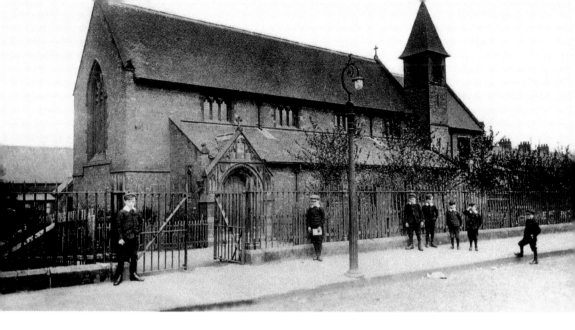

St Oswald's Church, *c.* 1910

St Oswald's Church of England church was opened to serve Hebburn Colliery's expanding community. Constructed between 1882 and 1883 to the designs of Charles Hodgson Fowler, it was completed with the addition of the chancel and bell tower in 1902. By then the church could seat over 300 people. Services are still held there, and the new houses being constructed nearby may help to swell today's more modest congregations.

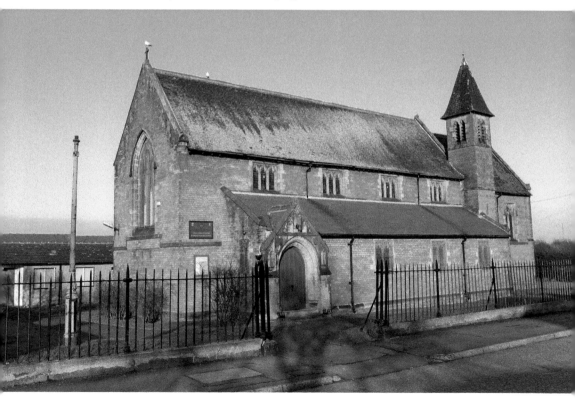

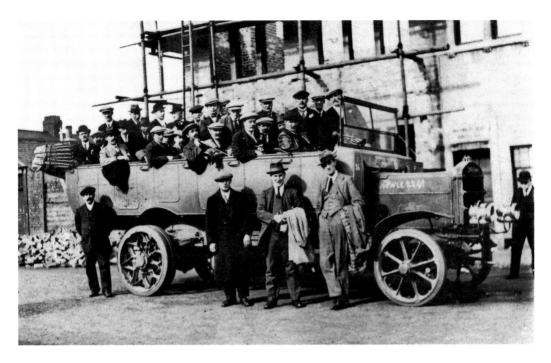

Colliery Club, High Lane Row, *c.* 1917

Hebburn Colliery Club (first opened 1907) was a pillar of the mining community – a venue for meetings and games as well as drinking. Working men's clubs and institutes began to appear in the late nineteenth century, but were not licensed to sell alcohol until 1902. Among bus trippers outside the club – which is under reconstruction after a fire – is colliery weighman John Coltman (flower in lapel) whose job helped to determine the pitmen's wages. A new club was built nearby in 1971.

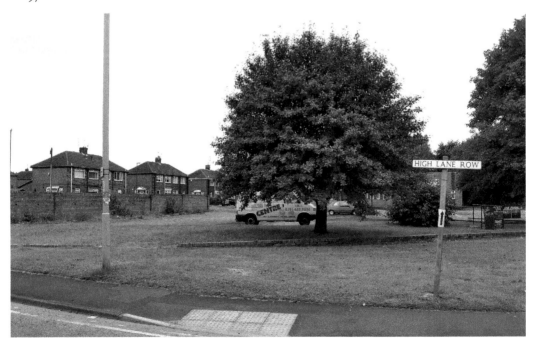

High Lane Hotel, *c.* 1970

Simpson's Hotel dominated the east side of High Lane Row. Originally built for Palmer's workmen, the big, barrack-style block was opened in 1919, then taken over by the Simpson Hotel Company and associated with the Simpson name. Simpson's was called a hostel but was advertised as an 'industrial hotel' and in 1975 lodged 200 men. High modernisation costs shut its doors. By 1998 it had been completely demolished to make way for a new estate, which includes Coppergate House, a small hostel for the homeless.

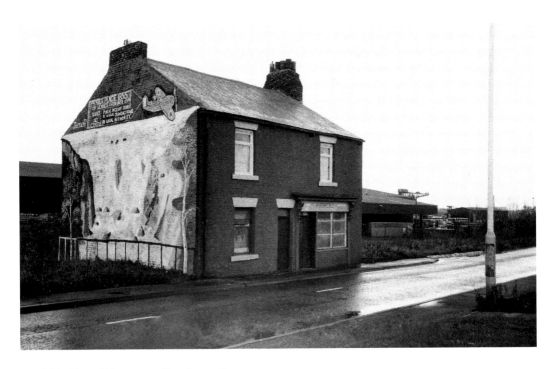

Patrick's Place, Wagonway Road, c. 1980

Patrick's shop wall mural brightened up drab Wagonway Road for years. 'Patrick's', a long established grocery and off-licence business, doggedly protested against compulsory purchase until finally succumbing to demolition in the 1990s. Occasionally still referred to as 'the low road', Wagonway Road lies close to the route once taken by coal trucks from 'C' pit to the riverside staiths. What is now a well-maintained carriageway was condemned in 1885 as the most 'crying evil in the district'.

Black Road Co-op and St Oswald's Road, 1963

Black Road's Co-op store opened in June 1900. It cost £2,000 and was built by the Co-operative Society's own workforce. The store's distinctive tiled façade is seen here from St Oswald's Road, and opposite the shop are the 1913 buildings of St Oswald's 'new' schools. Black Road, on which they both stand, was formerly Black Lane, which was a path through cornfields to the Black Staith, an ancient riverside coal jetty.

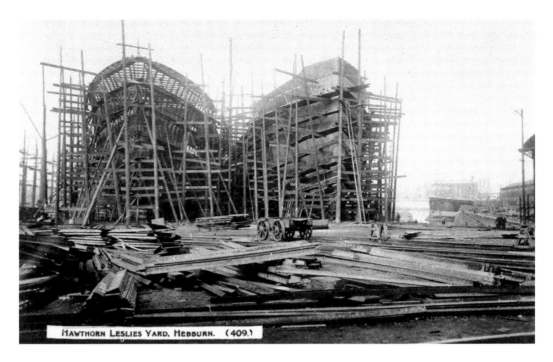

HAWTHORN LESLIES YARD, HEBBURN. (409.)

Leslie's Shipbuilders, *c.* 1900

Andrew Leslie turned a sandbanked location into a flourishing business. Auxiliary steam sailing craft *Clarendon* was the first vessel to be launched at Hebburn in 1854, followed over the years by more than 700 ships. After closure in 1982, the historic shipyard was used as a training centre, and now ship repairers A. & P. Tyne occupy parts of it. The company has helped keep Hebburn's maritime heritage afloat, though the grass grows over Hawthorn Leslie's old slipways.

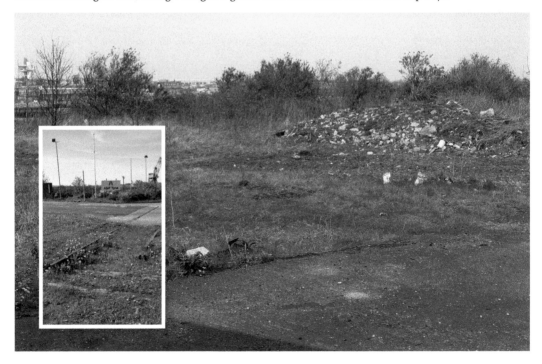

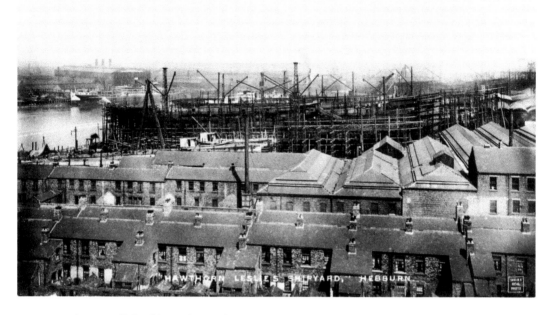

Hawthorn Leslie's Shipyard, 1916/17

After Andrew Leslie's retirement in 1886, his Ellison Street business amalgamated with Newcastle engineers R. W. Hawthorn and continued to build and repair ships in the Hebburn yard. Its slipways and 1866 dry dock are shown here beyond the foreground rooftops of Bonaccord Street. This was the heart of Hebburn's shipbuilding community, where most property was built and rented out by the shipyard founder. Now the old 'Leslie's Houses' have been replaced by a new Hebburn 'Village' and only a few sad fragments remain of the great enterprise that Leslie began.

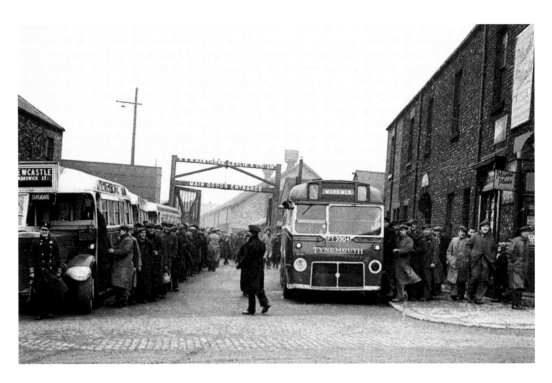

St Andrew's Street, 1950s

Hawthorn Leslie's experienced relative prosperity in the post-war years. Its workforce of around 2,000 was kept busy with a steady stream of orders, replacing wartime losses and then building oil tankers and cargo vessels for increasing world trade. The shipyard's independence ended in 1968 when it became part of Swan Hunter & Tyne Shipbuilders Ltd. The spot where workmen once filed onto buses at the shipyard's 'top gate' is now 'Jedmoor', part of the 1988 Hebburn Village housing development.

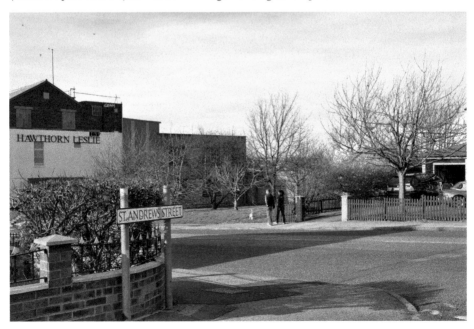

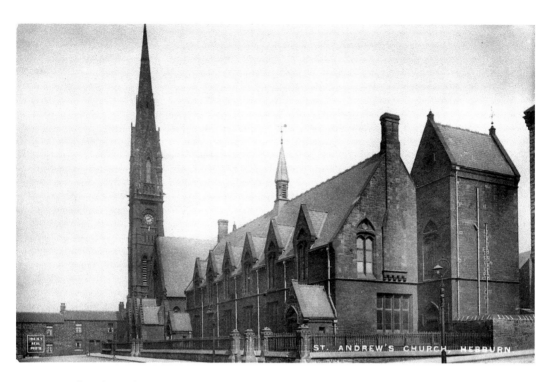

St Andrew's Institute, 1918

Like many Victorian industrialists, Andrew Leslie encouraged the education of his workforce. He subsidised the building of a new Mechanics' Institute, comprising schoolhouse, lecture and assembly rooms, which opened on Church Street in January 1872. It went on to be a focus for the community and was restored in 1985. Seven years later it was purchased by the local council to house business units and is now used by the health authority.

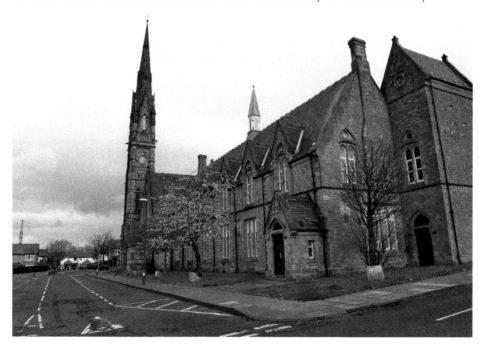

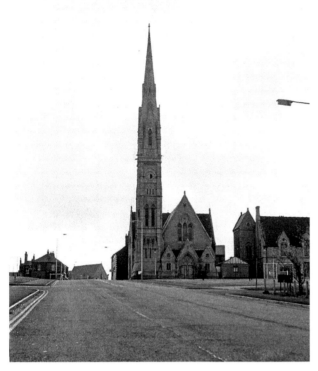

St Andrew's, *c.* 1970 and 2010
St Andrew's church was Andrew Leslie's greatest gift to the town. The shipbuilder donated much of the £10,000 reportedly paid for the building, which opened in 1873. It now towers over a reshaped Hebburn Quay, and the 1970s scout hut alongside it has been dismantled. The magnificent Grade II listed church has been disused for over four decades and it is unlikely that recent proposals for its conversion to a brewery would have been approved by Leslie, who as well as being a staunch Presbyterian was a Hebburn JP.

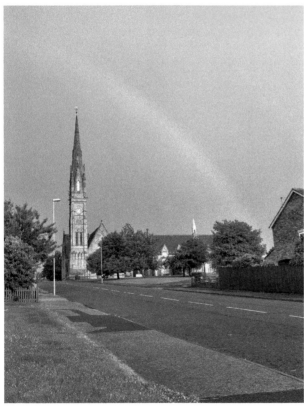

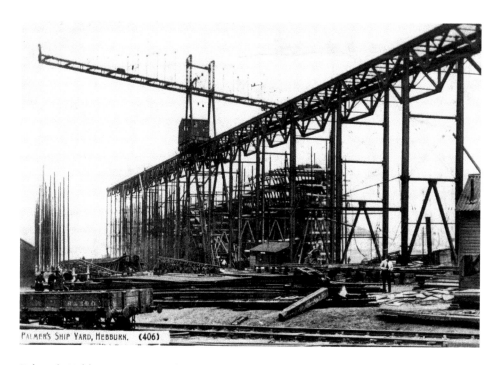

PALMER'S SHIP YARD, HEBBURN. (406)

Palmer's Hebburn, c. 1915 and 2011

Palmer's was another familiar Hebburn shipbuilding name. In 1912 the company acquired the yard adjacent to Hawthorn Leslie, formerly owned by Robert Stephenson, which contained the largest dry dock in the region. Shipbuilding ended there in 1931, but ship repair continued under the ownership of Vickers-Armstrong. An even larger dock was built in the 1960s and the Palmer's name survived until closure in 1970 with the loss of almost 1,000 jobs. A. & P. Tyne maintains something of the old Leslie & Palmer's tradition today, employing around 200 people. HMS *Bristol* is seen here in the modern dock.

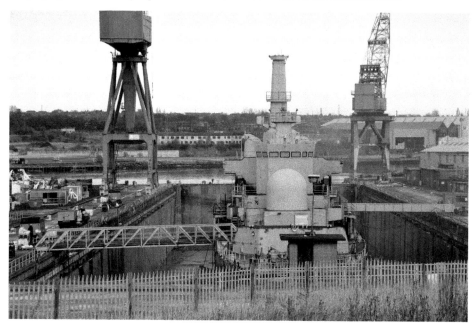

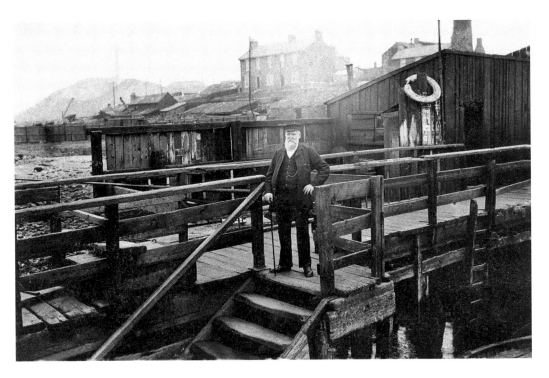

Stubbs' Landing, Hebburn Quay, 1911

Charlie 'Sculler' Stubbs proudly surveys his domain at Hebburn Quay. He hailed from generations of scullermen – watermen who rowed their fares back and forth across the Tyne. A small boat can be glimpsed on his left, and behind him are the Ballast Hill and the Tyne View buildings erected for the Tennant Chemical Company. In the 1970s, 75 acres of derelict riverside were landscaped to create Hebburn Marina, recently improved with a new walkway, lighting and decorative guard rails.

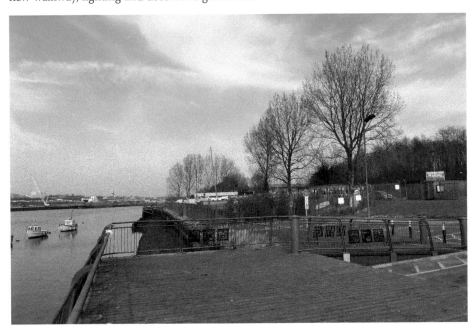

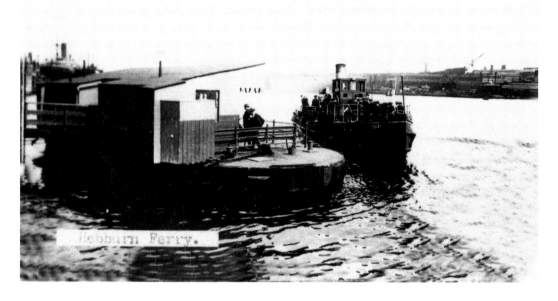

Hebburn Ferry, *c.* 1920

The first regular ferry service was established by Andrew Leslie in 1854. By the early twentieth century four steamboats shuttled between Hebburn, Wallsend and Walker. From 1939 Mid-Tyne Ferries introduced newer vessels, which at their peak carried over a million passengers annually. Tyneside's industrial decline had inevitable consequences, however, and Hebburn's last ferry sailed in 1986. Anglers have replaced hurrying crowds of shipyard and factory workers on today's Hebburn quayside.

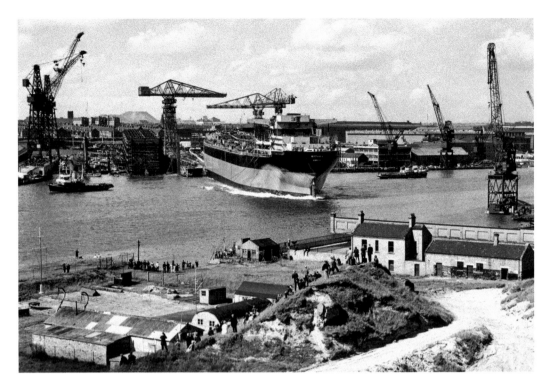

The Ballast Hill, 1964

Hebburn's Ballast Hill was a major riverside vantage point. This large artificial mound – one of many on Tyneside – was a centuries old accumulation of mostly sand and gravel, used to stabilise sailing ships before replenishment with outgoing cargo (usually coal). Although the practice ended when steam vessels began to use water ballast in the mid-nineteenth century the hill was not fully removed until the 1970s. Fine cross-river views can still be had from many of the houses now on the site.

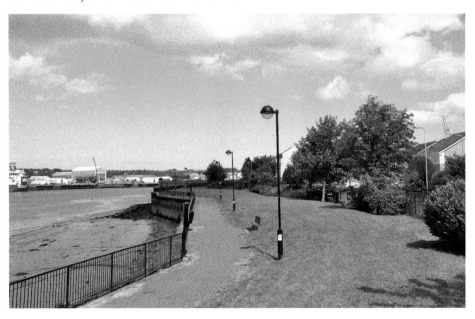

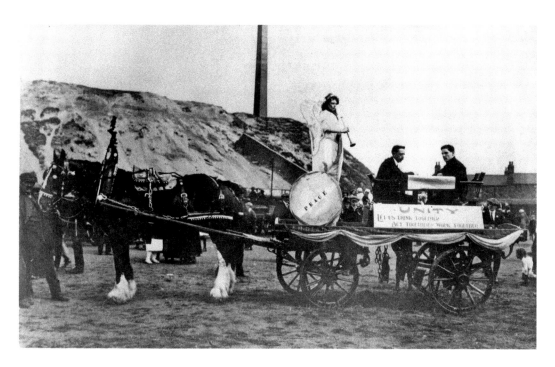

The Ballast Hill, *c.* 1925

Public celebrations once took place in Parliament Square, an open area next to the Ballast Hill. A fireworks display celebrating Queen Victoria's jubilee was given there in June 1887, and the photograph above shows a later town pageant. On board Reyrolle's 'Peace and Unity' cart is George Pawsey (centre, with wife Doris) – one of Reyrolle's original London employees, he moved to Hebburn in 1903. Formerly wasteground, Parliament Square is now the pleasant riverside neighbourhood of Springwood and Oakwood.

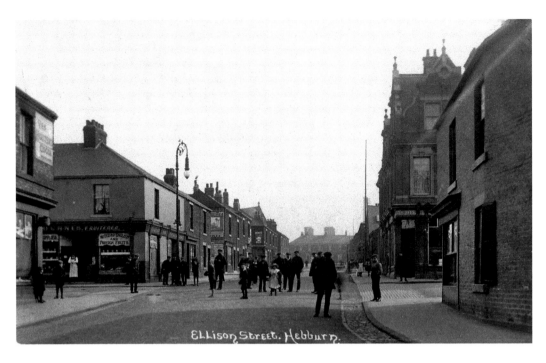

Ellison Street, c. 1911

Inquisitive townspeople stand and stare on the slope of Ellison Street at its junction with Lyon Street. Behind them are William Street and Cuthbert Street, part of an area of crowded terraces that were demolished from the late 1950s. They were replaced by a more spacious layout of modern housing and care homes, one of which is named after Ada Davies, a respected Hebburn Councillor.

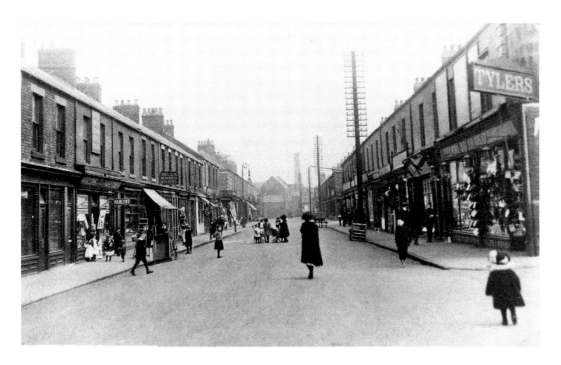

Carr Street, Early 1900s

Named after Ralph Carr, inheritor of the Ellison estates in 1870, Carr Street was one of Hebburn Quay's busiest thoroughfares. Most of the children pictured above appear to be well dressed and shod but a barefoot boy strolls past No. 19 Carr Street – ironically Alfred Tyler's boot and shoe shop. The chimney in the distant murk belongs to 'C' pit, but nothing of it or Carr Street now survives to obstruct the view of St Andrew's church and institute.

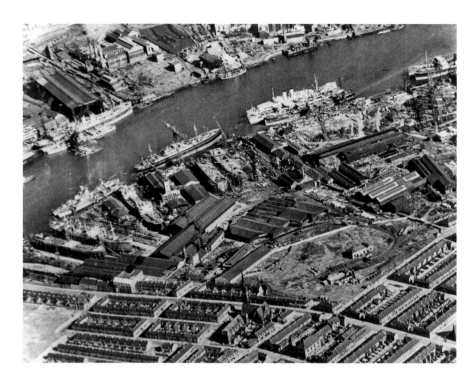

Shipyards and Town, 1946 and c. 1980

Dual aerial views illustrate changing fortunes for Hebburn's shipyards and the surrounding community in the post-war era. In 1946 vessels including HMS *Agincourt* and *Alamein* are anchored alongside the full berths of Hawthorn Leslie's and Palmer's. Around the scar of a redundant 'C' pit the lines of terraces are intact, yet within forty years most have been swept away, no ships are to be seen and Palmer's new dock, opened in 1962 before the company was acquired by Swan Hunters, stands empty.

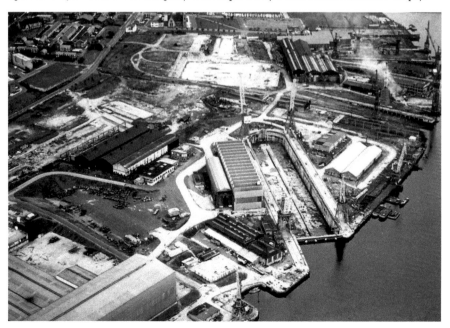

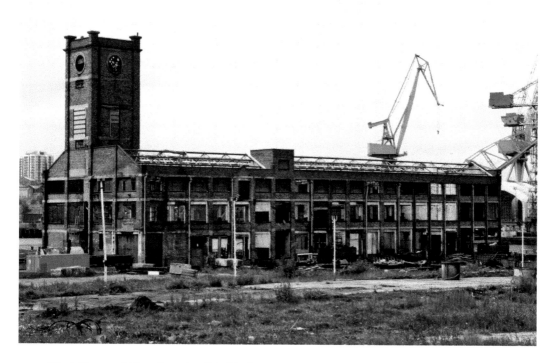

Clock Tower at Hawthorn Leslie's Yard, 2007

Time finally ran out for Hawthorn Leslie's iconic clock tower and office block in June 2007. This church-like industrial building somehow symbolised the discipline applied to timekeeping in the shipyards. Before the echo of the starting hooter had died away, zealous yard timekeepers swung the entrance gates shut, barring any latecomers. After several minutes the workmen were readmitted – at a cost to them of 15 minutes' lost earnings.

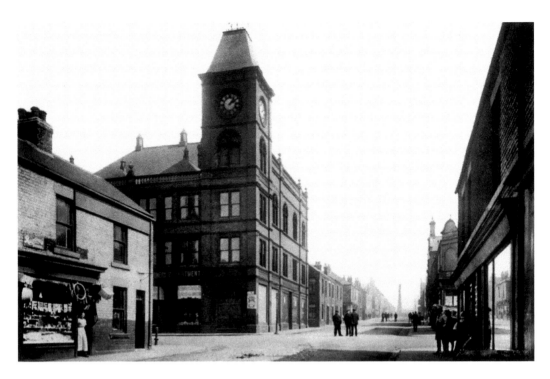

Albert Street and Co-op Buildings, *c.* 1910

Standing tall at the junction of Albert and Lyon Streets, the Co-op store was among the district's most impressive structures. Opened in June 1902 by local publican John S. Roy, the new building indicated the success of Hebburn's Co-operative movement; it had outgrown smaller premises on Lyon Street. With its upstairs assembly room, Hebburn's Store Hall became a popular shop and social venue. Of Edwardian Albert Street only the Albert Hotel (*centre right*, now Wardles) remains.

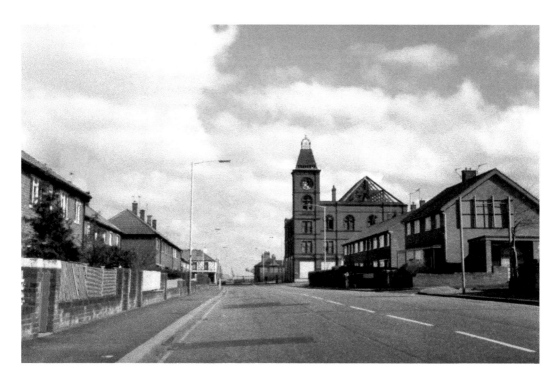

Lyon Street, 1983

By the 1980s, the Co-op building was in a sorry state. New houses had replaced much of the area's 'unfit' property and the Co-op had not used their flagship store for over a decade. A nearby newsagent occupied parts of it and efforts failed to turn it into a bingo hall before the bulldozers arrived in 1984. No attempt was made to rebuild on the site, leaving the more modern yet much plainer Lyon Steet seen today.

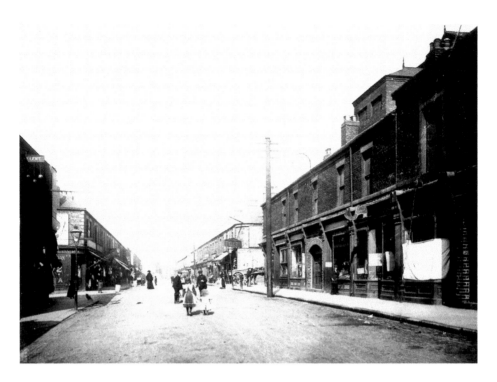

Theatre Royal, *c.* 1900

Hebburn's first purpose-built theatre was called the Grand when it opened on the corner of Lyon Street in 1897. A few years later, the 1,200-seater venue – tickets priced between threepence and two shillings – was retitled the Theatre Royal. A major attraction during the following years was Frank E. Franks, Hebburn-born comic and now largely forgotten music hall star. The theatre was destroyed by fire in 1950 and the back of it is photographed from Carr Street (*above*).

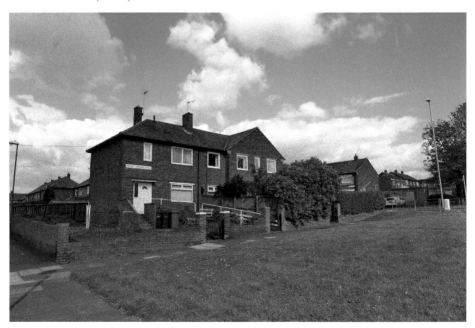

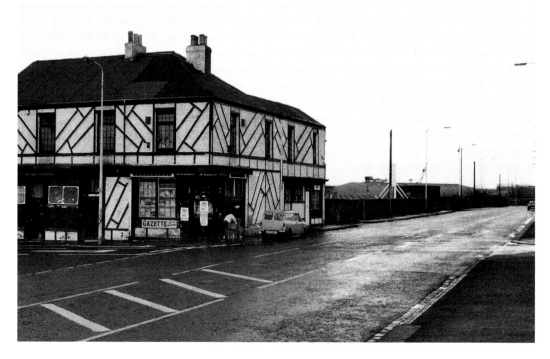

Junction of Ellison and Lyon Streets, c. 1970
Donohue's corner shop lingered on after the Hebburn Quay house clearances of the 1960s and '70s. It had succeeded Hewison's, also a newsagent, and shared the corner site with a private local history museum and a florist. Michael Donohue remains a 'paperman', and before these curious buildings were finally demolished to make way for modern housing in 1994 he transferred his business to a much busier location in the town centre.

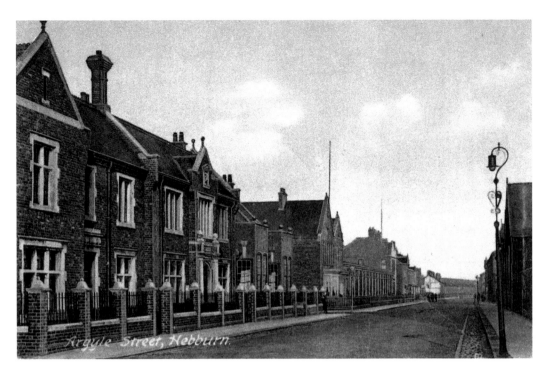

Argyle Street, Early 1900s

At the peak of Victorian expansion Argyle Street was the town's civic and administrative centre. Ranged along the street's long frontage were the impressive courts, police station and council chambers. The council convened in nearby Prince Consort Road or in public houses before meeting as the newly formed Urban District Council in the Arglye Street boardrooms on 31 December 1894. Hebburn has gained much on its journey through time, yet today's leafy but relatively empty Argyle Street illustrates what has been lost.

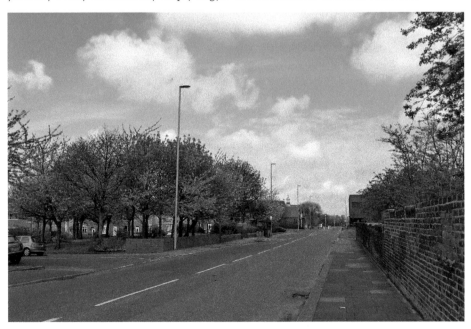

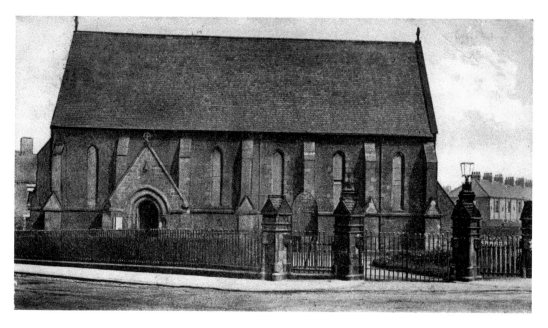

St Cuthbert's, Off Argyle Street, 1909

St Cuthbert's was designed by F. R. Wilson and built between 1872 and 1874 on land provided by Ralph Carr Ellison. It is claimed that the church lacks a spire because of a dispute with the builders, or, more tongue-in-cheek perhaps, because Andrew Leslie did not wish it to rival his mighty St Andrew's on Ellison Street. What is certain is that this postcard view shows the church before an extension in 1909, which almost doubled its length.

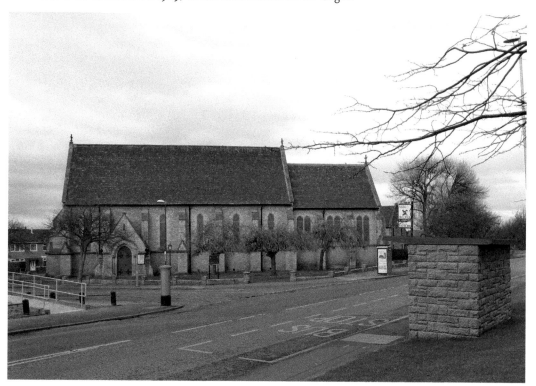

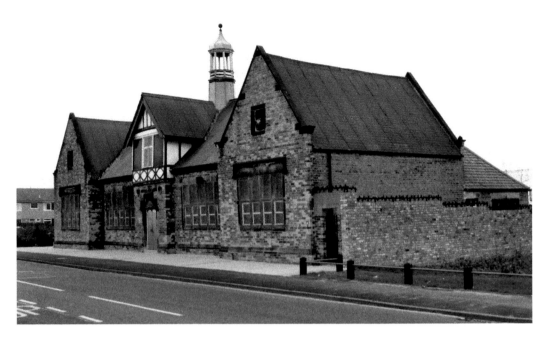

Hedley Sunday School, Argyle Street, *c.* 1995

Paid for by public subscription, this Sunday school was opened next to St Cuthbert's church on Easter Monday 1882. Shortly afterwards the Tudor-style building was named in memory of William Hedley, first vicar of St Cuthbert's who died at the age of just thirty-six. As well as being a schoolroom, the Hedley School building has found a variety of social purposes. During the Second World War it sheltered bomb victims, and it has recently been repaired and extended for even wider communal use.

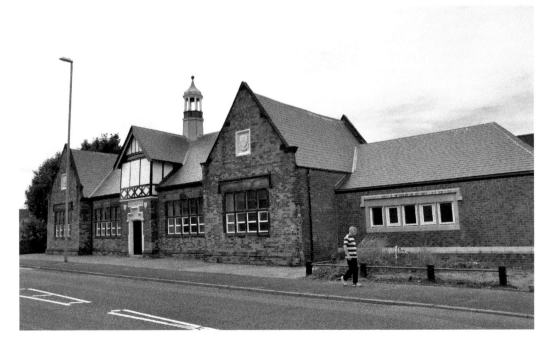

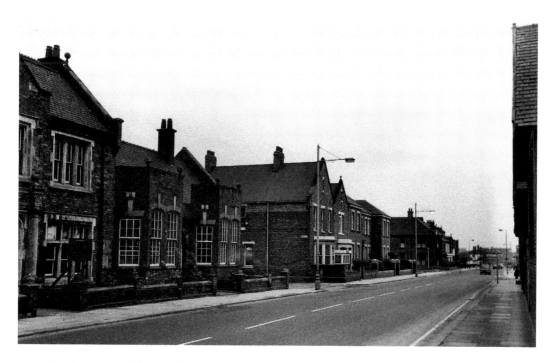

Argyle Street Police Station, *c.* 1970

Demolition of Argyle Street was underway when this photograph was taken. The old council chambers further down the street are waste ground and the fine police station buildings (*far left*) are only a few years away from demolition. Hebburn's police force experienced rowdy times in the early years. Opened in 1876, the police station survived an 1887 attempt to blow it up. Its ultra-modern but less eye-catching successor began operations on Victoria Road East in 1977.

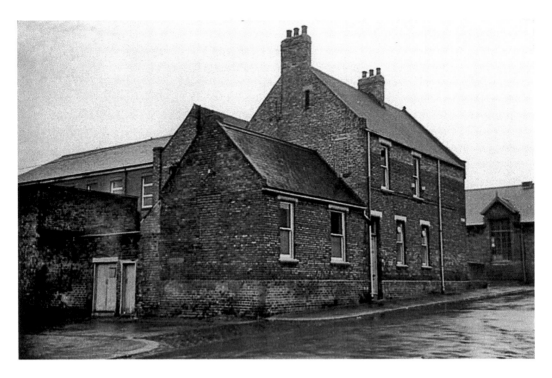

Bewick Street Doctor's Surgery, 1969

Of the doctors who practised in private surgeries like Bewick Street, cousins Michael and Peter Norman are particularly remembered for their dedication to the community, following in the footsteps of Michael's grandfather who campaigned to establish Hebburn's first hospital in the 1890s. Located in a house next to the clinic (opposite St Aloysius School), Bewick Street surgery had a pharmacy on the premises and became obsolete when a new health centre opened on Campbell Park Road in 1973.

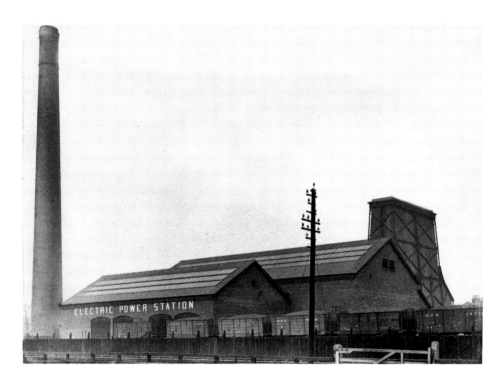

Power Station, *c.* 1900

Long before the National Grid, it was proposed to illuminate parts of Hebburn with cables from Leslie's shipyard. But it was not until after 1903 that gas lighting was supplemented by electricity from the Northern Counties Supply Company, which ran Hebburn's power station until superseded by larger Tyneside generators. In the 1930s its location beside the railway became Hebburn's social service centre, better known as the Power House. Clear views across the tracks have become obstructed but the area, now a substation, once again bristles with electrical equipment.

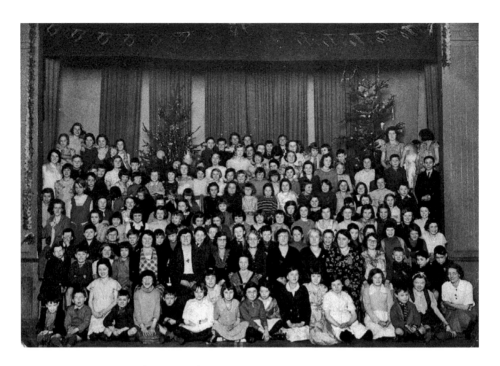

Power House, 1932, and Community Centre, 2012

Hebburn's Power House lifted the town's spirits in difficult times. With the help of unemployed men, the Newcastle Council for Voluntary Service converted the former power station between 1930 and 1934. It went on to host scores of activities, including dances, plays and pantomimes. Children are pictured here at Christmas 1933, on a stage installed a few months earlier. Hebburn's new community centre was opened in 1982 on Argyle Street, only yards from the site of the old Power House.

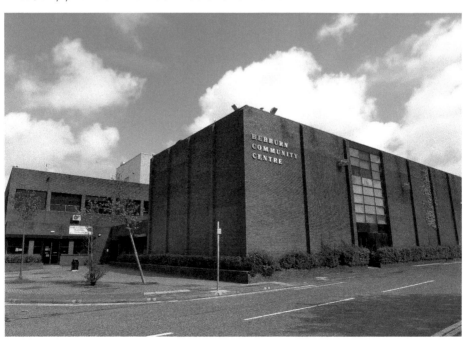

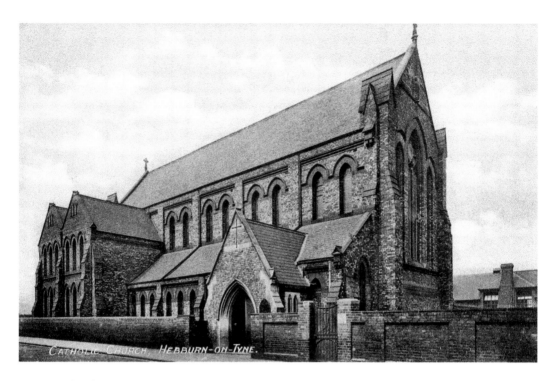

St Aloysius, *c.* 1925

During the Reformation of the 1500s, recusant Catholicism in Hebburn is first recorded when the Hodgson family hid priests at Hebburn Hall. Three centuries later a large immigrant workforce, many of them Irish Catholics, led to the provision of such a large building as St Aloysius. The French-style church is pictured here from Bell Street, with the old school buildings behind. A parish hall now stands alongside and a new Catholic school has been built further down Argyle Street.

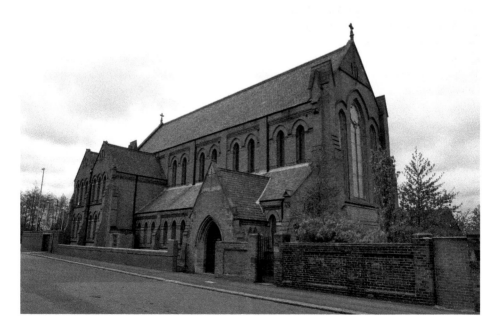

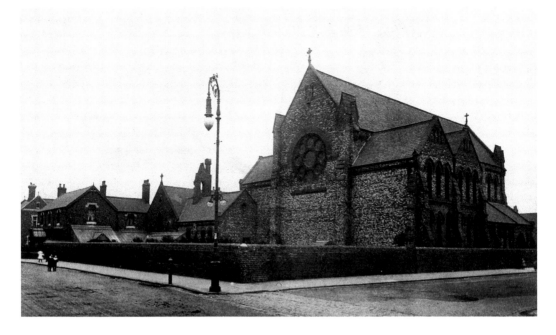

St Aloysius, *c.* 1910

Hebburn's Catholics once travelled to Felling and Jarrow or used houses and even pubs in Hebburn to hold religious services. But in 1872, the first Catholic school and chapel was opened on the corner of Prince Consort Road and Argyle Street – a site then extended for the construction of St Aloysius. The foundation stone of the new church was laid in October 1886 and it was opened in June 1888. The Lady Chapel, seen projecting from the nave, was added after the First World War.

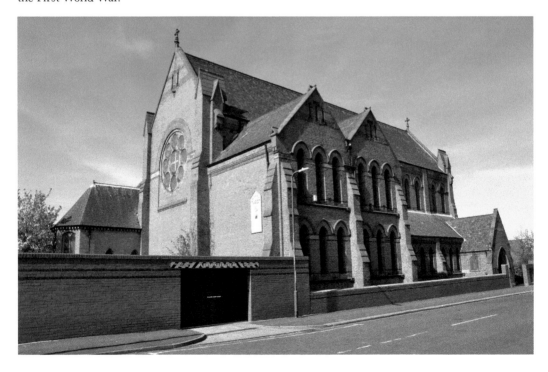

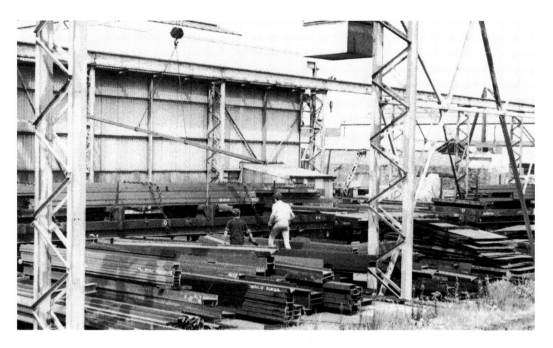

Frazer's c. 1965

In 1899, Newcastle-based Robert Frazer & Sons established their Hebburn business next to the railway, on a plot previously used for sailcloth and rope making. Because of the industrial lubricants the company supplied, it was known initially as the 'grease works', but it built a reputation on structural engineering and steel supply. Nearly 150 years later, present owners Phoenix Steel still distribute steel from the site, although it is now stored indoors.

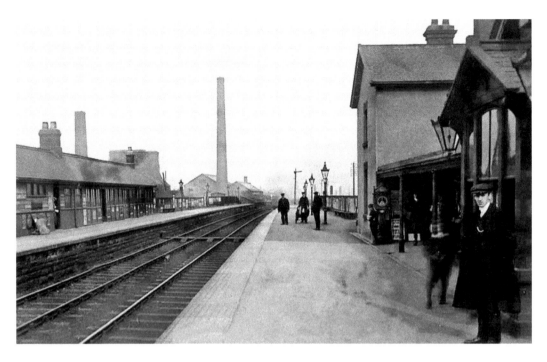

Railway Station, *c.* 1910

Hebburn station was opened in March 1872, on a new Pelaw to Tyne Dock line. This linked Newcastle and South Shields directly for the first time, benefiting day trippers and travelling workmen alike. In 1889 Hebburn's single booking office was unable to cope with customer queues and a decade later there were sixty trains daily. There are as many members of staff as passengers in the image above, however, while in the distance an eastbound train has just steamed past the power station.

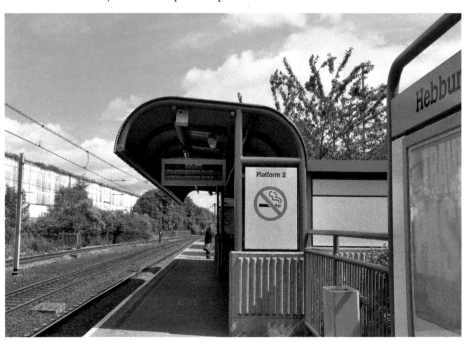

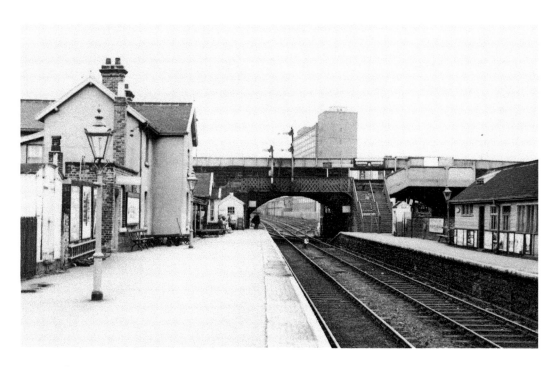

Railway Station, 1965

Most of the Victorian platform buildings pictured above survived until station 'destaffing' in 1969. By 1972 only a few destination boards and antiquated gas lamps remained. But the line survived and the station prospered with the construction of the Metro. Reopened in 1984 with a second platform to the west, Hebburn's new, streamlined station is now a busy part of Tyneside's successful light-rail system. (Note the absence of the demolished Reyrolle office block in the lower photograph.)

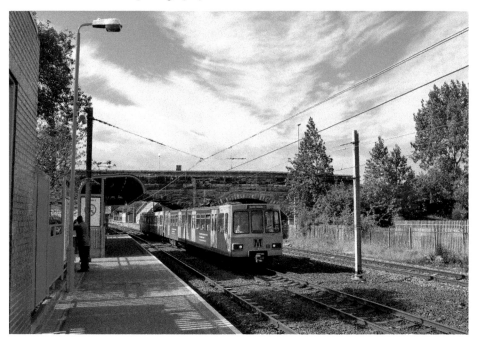

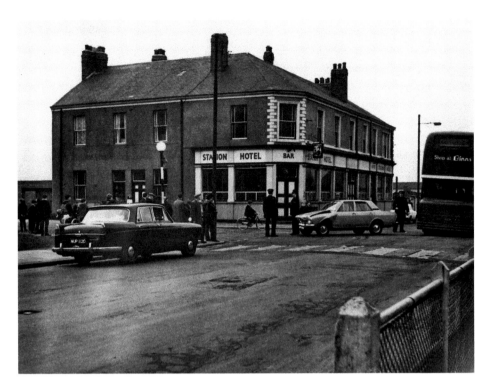

Station Hotel, 1967

A road smash focuses the photographer's attention around the Station Hotel. The pub was christened 'Roy's' after Edwardian publican and local councillor John Styles Roy. His name lingered on and after a 1970s makeover his old Station Road bar became 'Leroy's' nightclub. It too was no stranger to dramatic incidents – gunshots were fired there in 1991 – but it is now the much healthier site of the Glen Primary Care Centre.

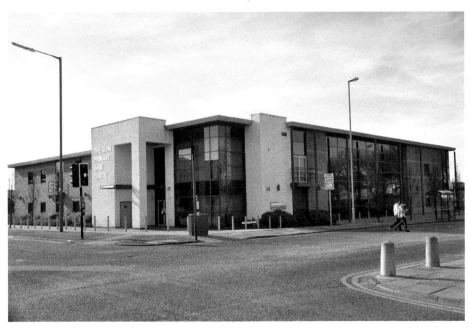

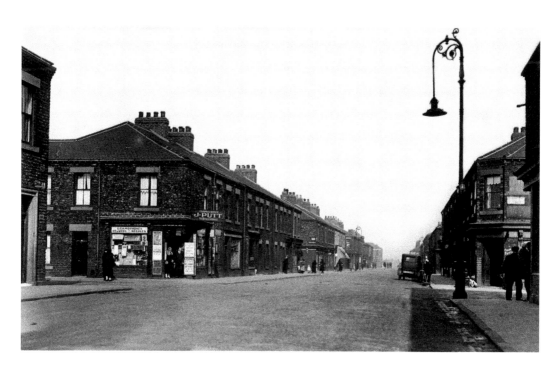

Tennant Street, c. 1930

History is often revealed through street names. Charles Tennant's chemical company began at Hebburn riverside in 1864 and later Newtown's Tennant Street, where many factory workers lived, became a bustling mix of shops and houses. Above, Putt's tobacconist (afterwards Murray's newsagent) displays its sign and nearby hang the three balls of Davison's pawnbroker – a true sign of the times. Following construction in the 1960s of the flats and shopping centre, only the distinctive outline of Aln Street Masonic Club (built in 1925) remains in the background to connect present to past.

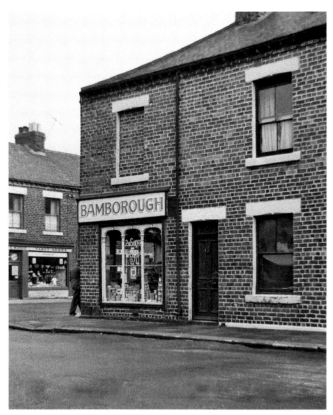

Rose Street, c. 1963
J. Bamborough once sold footwear and later ran this grocery shop on Rose Street. This was at the centre of Hebburn Newtown, referred to in 1874 as Tennant's Village in deference to the industrialist family who leased out houses near their chemical works. Rose Street was flanked by Shamrock and Thistle Streets – names reflecting the national diversity of Hebburn's early workforce. Rose Court and a redundant nameplate for Shamrock Street are reminders of the original street plan.

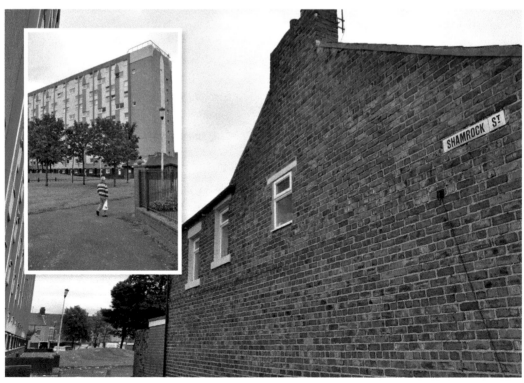

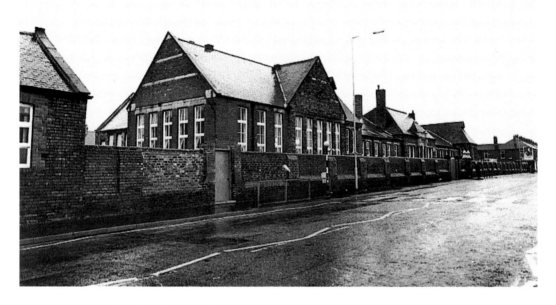

Newtown School, Station Road, *c.* 1975

Costing £8,000, Hebburn Newtown School opened in May 1875. Established under the Victorian School Board system, it originally housed infants and girls in one section of the building, and boys in the other. After the construction of Clegwell Senior's in the 1930s the Newtown school became a primary until closure in 1984, when pupils were transferred to the renamed Bedewell on Coleridge Square. Landscaped by South Tyneside Council in 1989, the site is now Fountain Square Park.

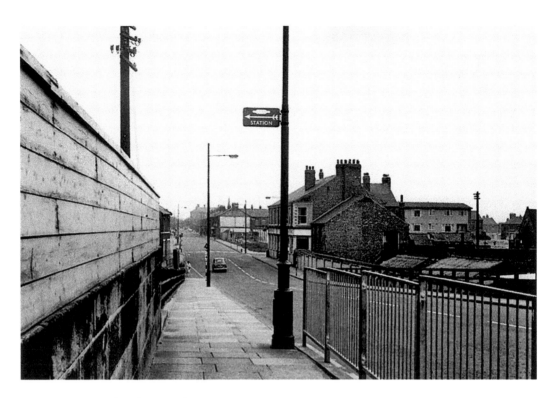

Station Road Railway Bridge, 1963

A view from Station Road Bridge shows Newtown in the making. Beyond the Station Hotel (*centre right*), houses have been torn down for the new shopping centre to come, and Glen Street Wesleyan church is glimpsed (*far right*). These buildings have gone, but Hebburn Hall and the spire of St John's remain today as distant landmarks.

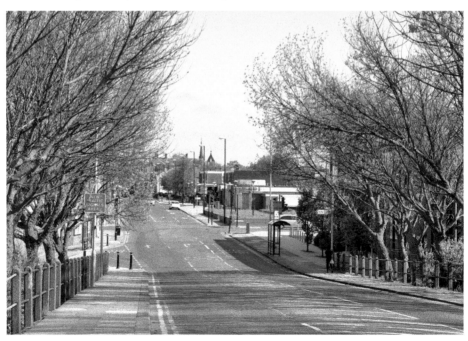

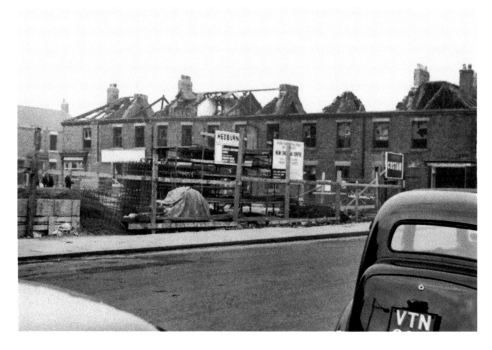

Shopping Centre, 1967

Plans were made during the 1950s for new housing and a modern shopping development in Hebburn's original Newtown district. Designs for the Station Road area scheme (influenced by Harlow in Essex) were approved in 1958 and the work was carried out in stages over the next decade. An old terrace is shown here on the brink of demolition in 1967. Its traditional corner shops are empty shells, being replaced by the brand-new shopping precinct taking shape nearby.

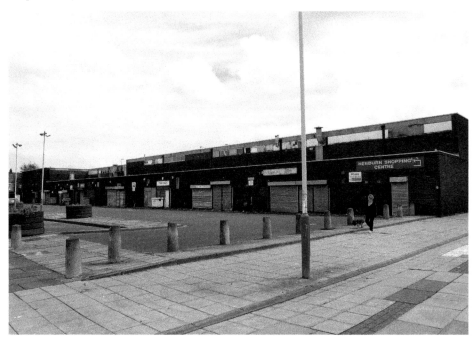

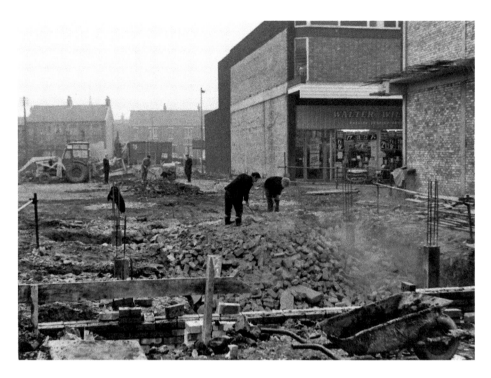

Shopping Centre, 1967

Building work continued after the shopping centre's first nineteen units were opened in late 1967. They were occupied by well-known Tyneside businesses like Walter Willson's – the 'smiling service grocers' – and smaller local traders such as Hill's decorators and Sheldon's bakery. All of the shops have changed hands several times over the years as the centre has increasingly struggled against competition from national retail chains and out-of-town shopping malls.

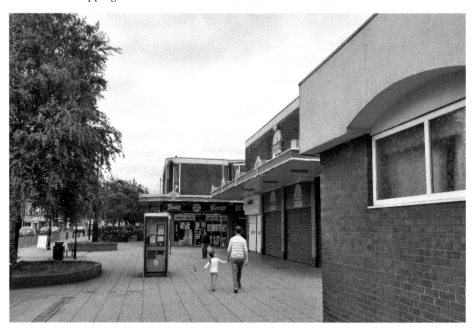

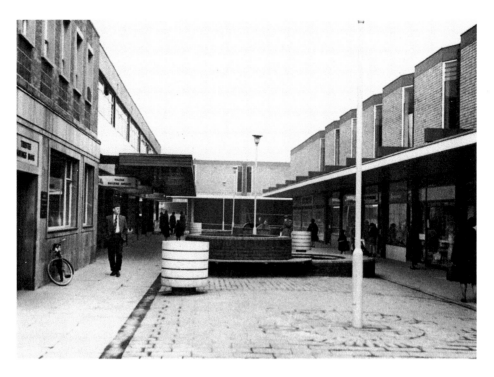

Shopping Centre, St Johns Precinct, 1967

Fresh and bright when it was built in the 1960s, Hebburn's shopping centre has deteriorated like many similar structures of that era. Over the decades shrinking trade and vacated shops have caused the centre to become rundown, making its repair or replacement a major local issue. Hopes for a £40 million redevelopment were dashed in 2010 and Hebburn town centre continues to wait for a long overdue regeneration.

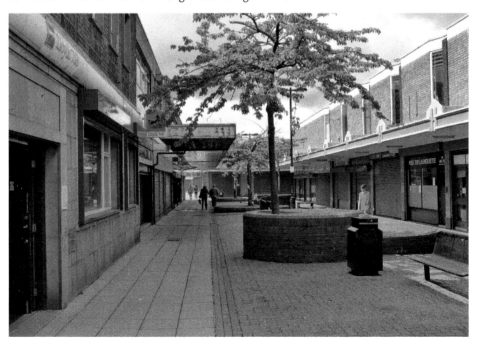

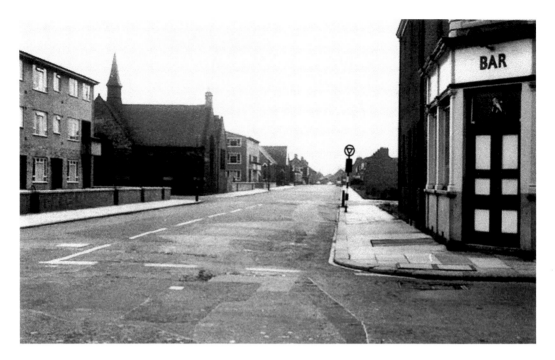

Glen Street, 1963

Slum clearance was a priority in post-war Hebburn. Poor housing across the town was earmarked for clearance and a compulsory purchase order was issued for the Glen Street neighbourhood in 1957. Some of the worst properties were flattened and the Council proudly unveiled plans for the 'all-electric' flats of Glen Court, seen here on the left. They were recently demolished and other 1960s maisonettes built along the street are now following in their footsteps.

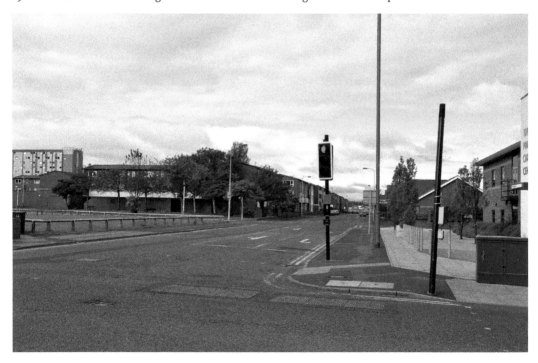

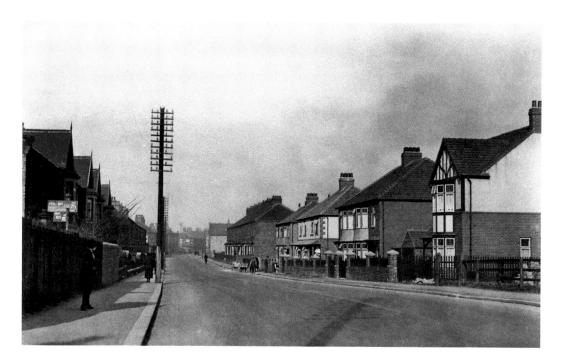

Victoria Road West and Newton Terrace, c. 1930

Victoria Road, Hebburn's 'high road', follows a traditional east–west route between Newcastle and South Shields, though it has been slightly diverted around Hebburn Hall since the eighteenth century. Finishing touches are being applied to semi-detached houses on the right, while on the left – the site of North Farm – fresh eggs are for sale. Patches of countryside remained in Hebburn during the 1930s, and the large tree at the roadside is a reminder of that rural past.

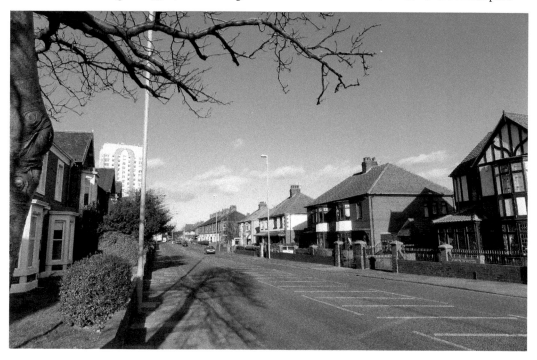

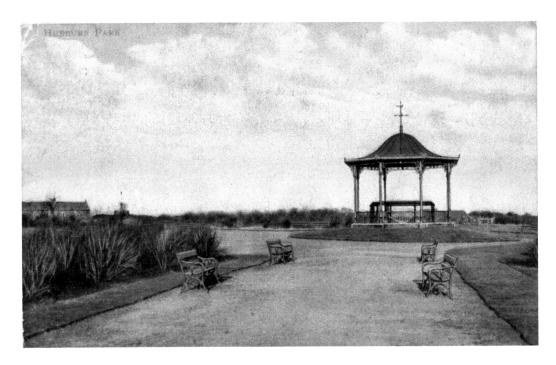

Carr Ellison Park, c. 1908
From 1897, Ralph Carr Ellison allowed 20 acres of land around Hebburn Hall to be used as a public park. Rent was charged for it until 1920, when the park was gifted to the town. By then it had tennis courts and bowling greens, a bandstand and an aviary. The park kept a pet badger in 1899 and though such an oddity may now be only a distant memory, tennis is still played in this popular park and a band performs at the annual bowls tournament.

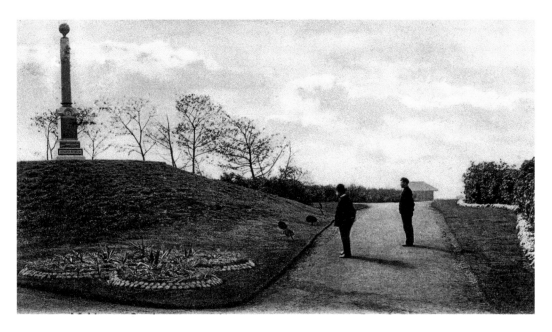

Boer War Memorial, *c.* 1903

Hebburn servicemen killed in South Africa in 1900/01 are commemorated in Carr Ellison Park. Six names are inscribed on the Boer War memorial, which is a tall granite column set on a triple pedestal. It stands on a mound next to the 'Dene' – previously a sunken garden in Hebburn Hall and before that an ornamental pond. The monument continues to be a magnet for local children who play on the miniature cannon next to it.

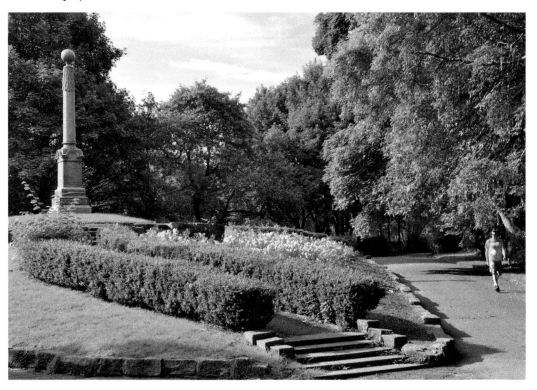

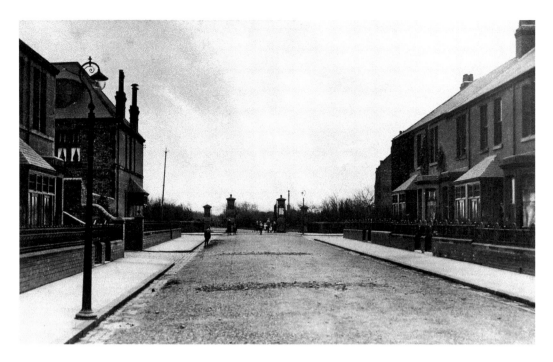

Park Road, *c.* 1910

Park Road was relatively new when the first photograph was taken. These spacious late Victorian and Edwardian terraces were built over former plantations on the old Hebburn Hall estate. A century on little appears to have changed apart from the ubiquitous cars and lost view of the Boer War memorial. Helped by its proximity to Carr Ellison Park the street has retained a visual character and appeal, which were recognised in 2007 when it was included in the Hebburn Hall Conservation Area.

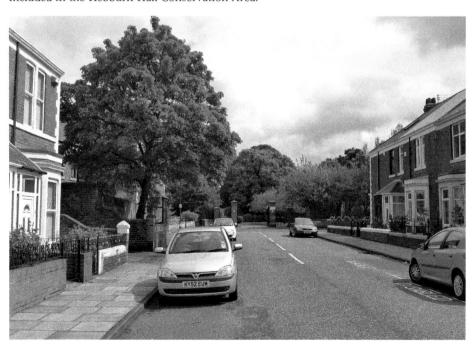

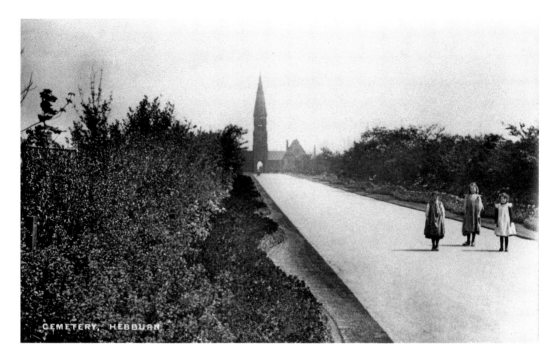

Hebburn Cemetery, c. 1905

Prior to the opening of Hebburn Cemetery, many local burials were carried out at Jarrow. Bishop Westgate of Durham consecrated Hebburn's new cemetery in June 1890, set out in 9 acres of land acquired by the Hedworth, Monkton & Jarrow Burial Board. The long main driveway led to a pair of mortuary chapels, the north originally Nonconformist and the south Church of England, with an arched carriage gateway between them.

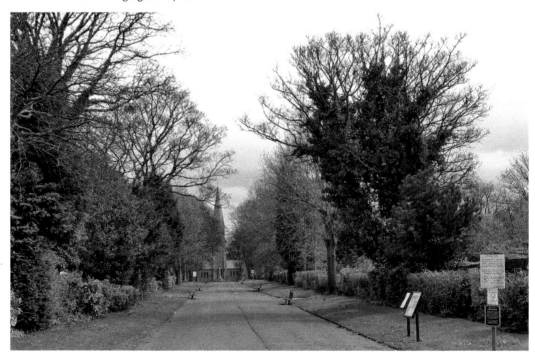

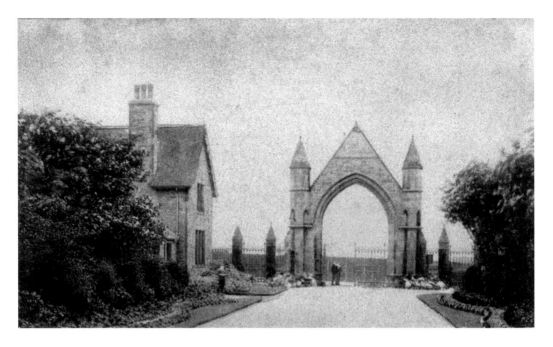

Cemetery Entrance Gate and Lodge, *c.* 1905

A hand-tinted postcard from the early twentieth century illustrates the cemetery's Gothic entrance on Victoria Road (around that time still marked on maps as Shields Road). Like the other cemetery buildings, the large sandstone gateway was by Frederick West, surveyor to the local Burial Board. Park & Cemetery Superintendent Mr Thompson, first tenant of the entrance lodge on the left, seems to have made an impression in Hebburn. For years the cemetery was known locally as 'Thompson's Garden'.

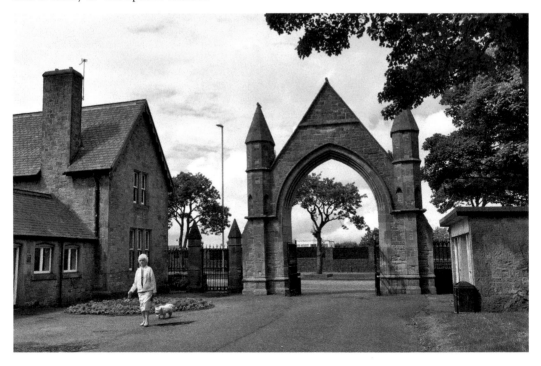

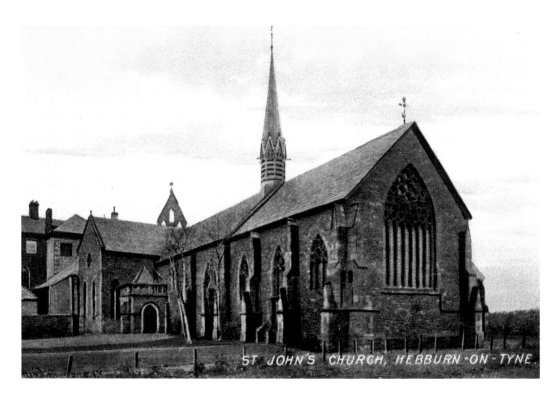

St John's Church, *c.* 1925

St John's parish was created in 1885 and the church of St John the Evangelist was consecrated two years later. Converted from Hebburn Hall's elongated west wing by architect F. W. Wilson, it was constructed for a congregation of over 500 and has a seven-light window and an interesting 'wagon-shaped' timber roof. Apart from modifications to the porch and the addition of a community building near it, there have been few external alterations. However, the church windows are now protected with wire mesh.

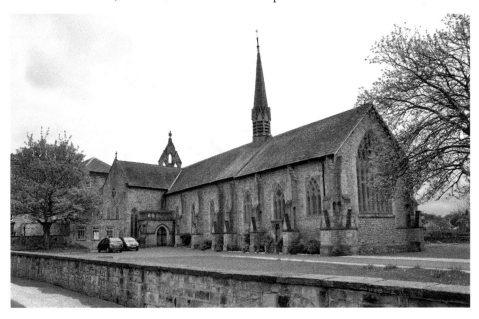

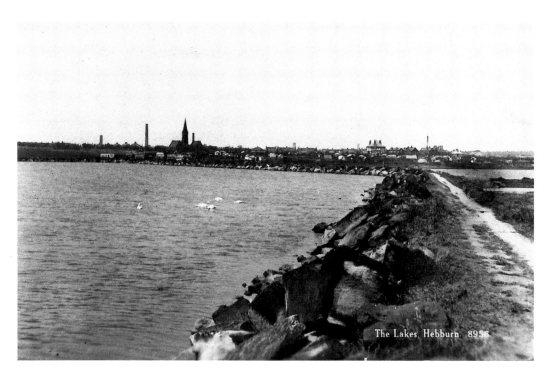

The Lakes, *c.* 1930

Two of Hebburn's four lakes are clearly seen here. Also called 'Hebburn Hall Ponds', they were reservoirs for local works. Created in the nineteenth century, they are fondly remembered as a picturesque contrast to the surrounding industrial town. The lakes were also used for boating and fishing, and in 1907 they were described as a wildlife haven 'teeming with trout'. Drained by 1968, schools and houses now stand in their place.

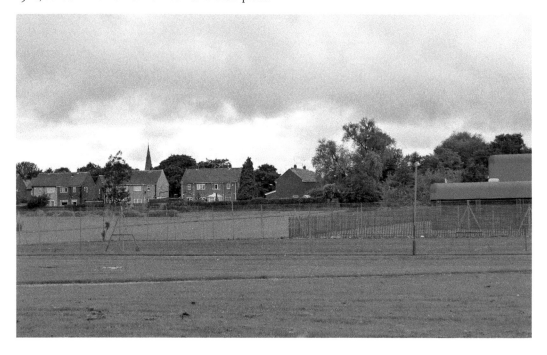

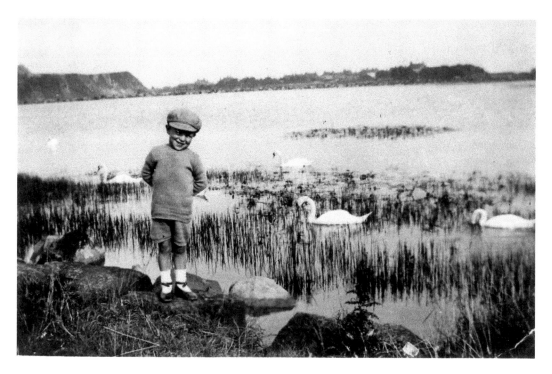

The Lakes, 1929

Leisurely walks often began at the 'first' lake, outside the park's east gate. Young Gordon French poses happily there, with the slag heap and Monkton village behind him. Such pleasant scenes conceal a darker side however. Several drowning tragedies occurred over the years, some involving children at play. Perhaps the new school buildings completed on the site may be seen as a fitting tribute to them all.

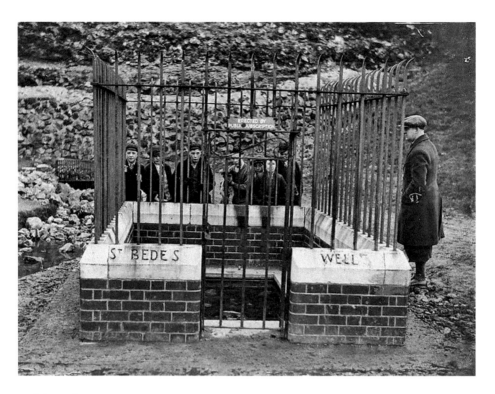

Bede's Well, 1932

St Bede's Well is shown here after a publicly funded restoration in the late 1920s. The railed enclosure was erected as protection not just from inquisitive schoolboys, but also from the dumping of slag that was in full swing at that time. Although historical proof is lacking, this former old watercourse in a small valley of the Bede Burn is traditionally associated with the famed local saint. It was given a new look in the 1980s and in 2012 is ready for another.

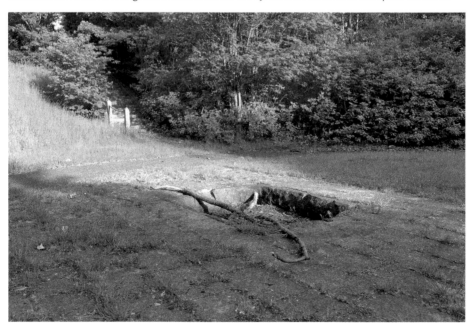

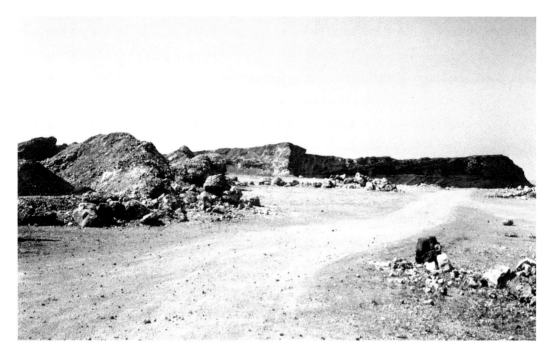

Slag Heap, 1963

Sometimes described as a miniature Table Mountain, the slag heap overshadowed the town's south-eastern boundary for many years. It began to take shape in the nineteenth century when waste from local ironworks was dumped in the fields. Molten slag lit up the night sky and by day smoke rose from the solidifying heap. Hebburn's unwanted landmark was steadily removed in the 1970s and found a useful purpose as road building material. Now landscaped, the former tip has become scenic community woodland.

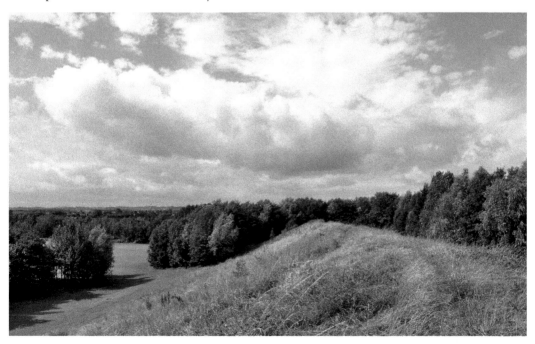

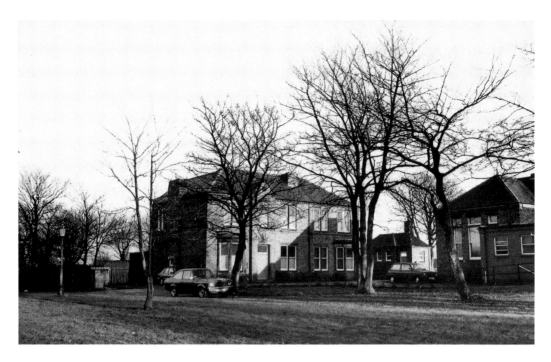

Old 'Fever Hospital', East View, *c.* 1970

Isolation hospitals were a major weapon in the fight against infectious disease. Hebburn's own fever hospital was opened on the edge of the expanding town in 1899, replacing a smaller temporary construction. It was later enlarged to treat smallpox until the 1940s and TB until 1956 when it was dedicated to the care of the chronically ill. Afterwards it became a geriatric unit and is now used as a specialist centre by the NHS.

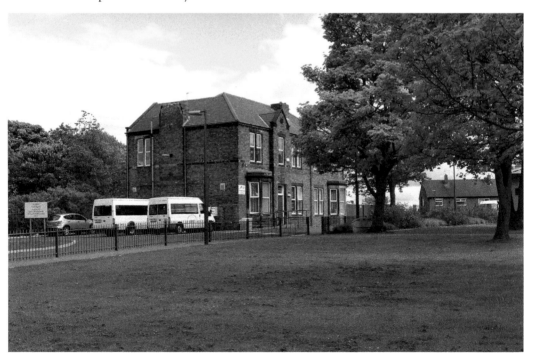

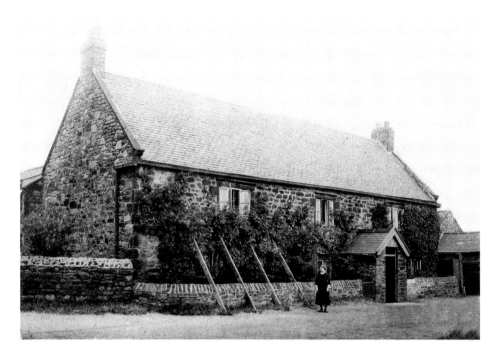

Redhouse Farm, *c.* 1920

Redhouse Farm was a remnant of pre-industrial Hebburn, one of several farmsteads scattered around the old Hebburn Manor. It first appears on an 1859 map as a substantial range of buildings titled 'Hebburn Red House', but may have been in existence since the sixteenth century. Usually linked to the Charlton family, the picturesque farmhouse was swept away by the growing town in the 1950s. It stood at the top of Ushaw Road (*below*) and is recalled in the name of Redhouse Road nearby.

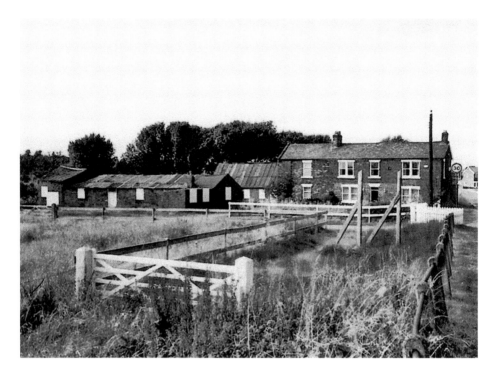

Mill Lane, Mill Farm, 1980

Mill Farm was the last of Hebburn's outlying farmsteads to be developed. Dilapidated farm sheds (*seen above*) were replaced by the Cock Crow Inn, opened in 1995. The £1 million pub and restaurant was named after the Cock Crow – an historic riverside building swallowed up by shipyard expansion in the latter nineteenth century. Not far from the old house were the Cock Crow Sands, a hazardous river obstacle, finally cleared by the Tyne Improvement Commission after it was established in 1850.

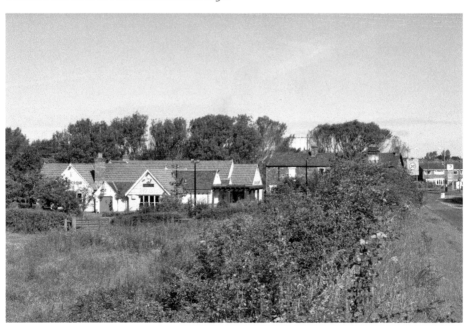

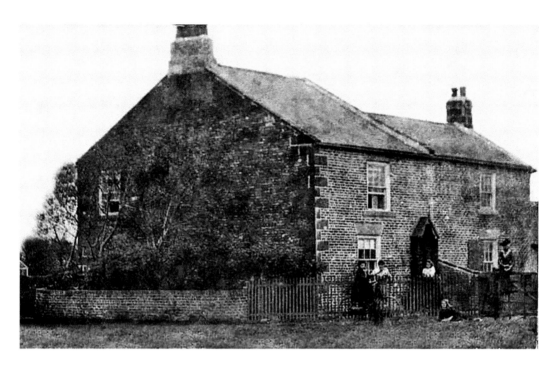

Cleg House, *c.* 1900

Cleg House was situated off Victoria Road, not far from today's new Keelman's Row School. An auction disposed of the house contents in June 1890 after the death of occupant Thomas Stothard, whose family were local farmers. A decade later members of the Branch family pose here outside Cleg House, which was well known for its adjacent water source. The 'Clegwell' was a reliable local supply that colliery women crossed the fields daily to use.

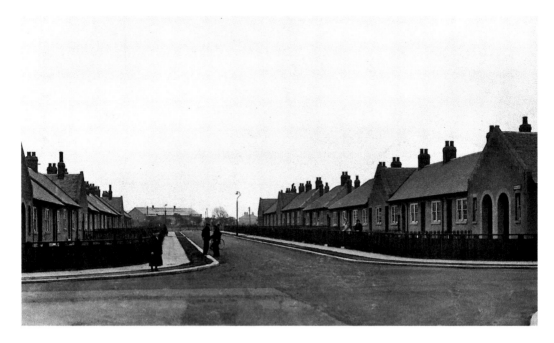

Byron Avenue and Hebburn House, 1930s

Hebburn House is largely forgotten and was rarely photographed. It is silhouetted in the right background of this Byron Avenue portrait, taken when the bungalows on the 'writers' council estate were relatively new. A colliery official lived at Hebburn House on Hedgeley Road until 1931 and the local fire brigade used it afterwards. The old house was knocked down in the 1970s and the Father Walsh Centre, opened in 1991 by Labour minister Robin Cook, now stands in its place.

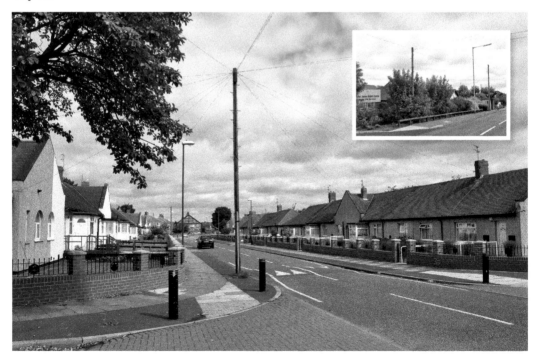

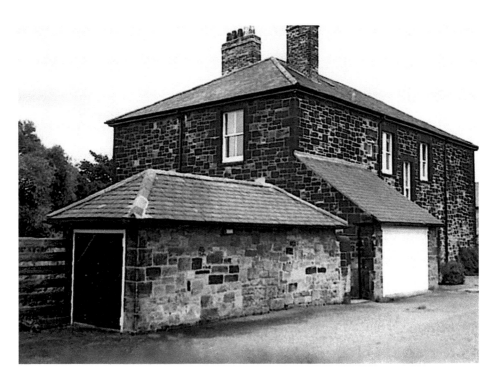

St Cuthbert's Vicarage, Witty Avenue, 1980

Building work on St Cuthbert's vicarage began in 1876. The ten-roomed residence was erected on farmland about a mile south of St Cuthbert's church, which was then being hemmed in by the expanding industrial town. Revd William Hedley ceremonially cut the first turf at the new site, but only enjoyed its relative solitude for a few years until his premature death in October 1882. Hidden behind twentieth-century housing, the vicarage was eventually replaced in 1994 by Hebburn Court, a fifty-five-bed care home.

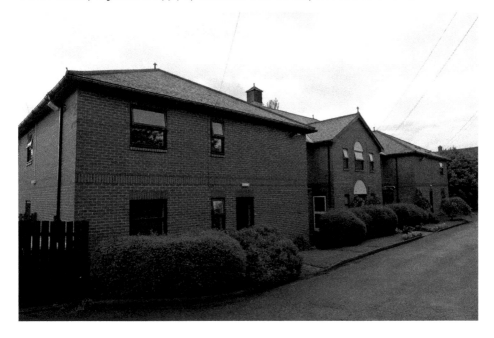

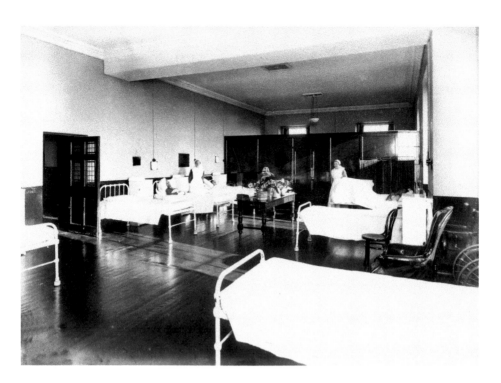

Hebburn Infirmary, 1934

A local metalworker was the first patient to be treated at Hebburn Infirmary when it opened in August 1898. Before then casualties were taken to Newcastle, but Ralph Carr Ellison allowed part of Hebburn Hall to become a hospital and by 1914 the publicly funded institution was equipped with emergency wards and X-ray facilities. From 1966 until its closure in 1976 the infirmary housed a geriatric unit and now, after conversion to luxury apartments, fee-paying guests occupy the former wards.

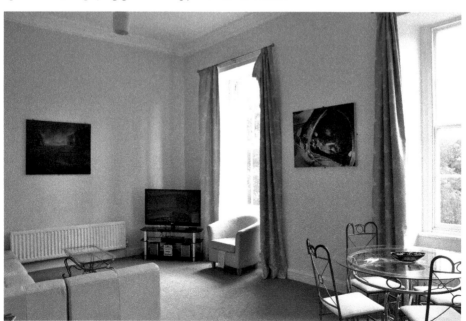

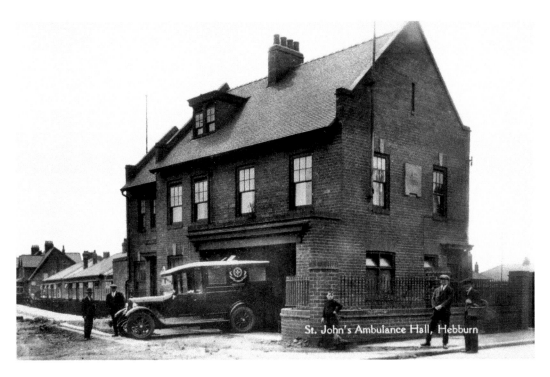

Ambulance Hall, Victoria Road West, *c.* 1930

St John's Ambulance Association was established in 1887 and a Hebburn branch was formed shortly afterwards. By 1902 it had over thirty members and training sessions were conducted by local doctors in private houses. The Ambulance Hall opened in 1926, appropriately enough on the corner of St John's Avenue and Victoria Road, and was equipped with a garage, now used by the taxi company that presently occupies the building.

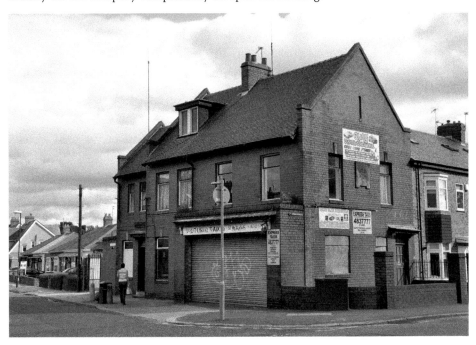

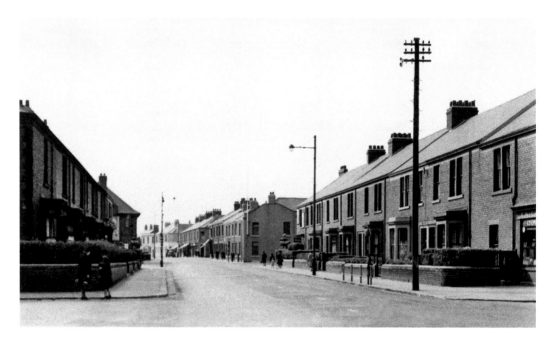

Victoria Road East, c. 1950

Apart from Hebburn's own skyscraper, Durham Court, the view towards the town's main crossroads appears largely unchanged. Victoria Road East is still lined with substantial terraced houses, but at the traffic lights on the right Hudson's newsagent's is now the Black and White barber shop. Across the road, the Protestant Conservative Club, known as the 'Bentinck', has never surrendered and further along the old Argyle pub, once called Claps and now the Roadhouse, stands alone.

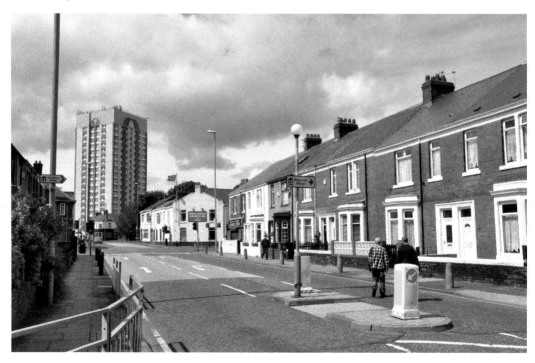

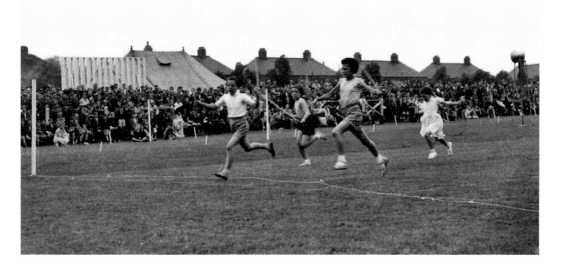

Leslie's Sports Field, Victoria Road, *c.* 1957
Opened in 1920, Leslie's Recreation Ground was a focus of local sporting activity. Cricket, football and bowls were played there, and the annual Sports Day was a popular event in the social calendar. Crowds flocked to the athletics, which featured not only local children but world-beaters like Derek Ibbotson, who competed in July 1957. Many fine footballers also graced the Leslie turf, several progressing to professional stardom. Sold off in 1990, the much loved field is now Sullivan Walk estate.

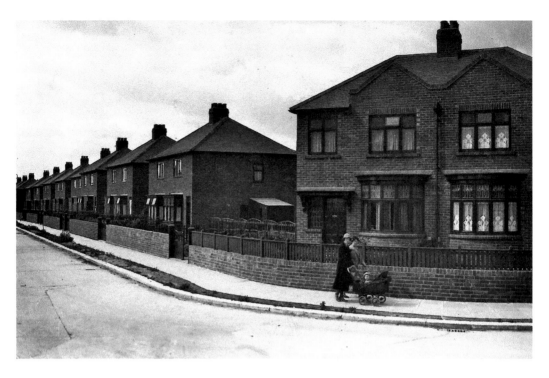

Lambley Crescent, *c.* 1938

Hebburn expanded during the 1930s despite the prevailing economic gloom. New houses to the west of the town centre on the Reservoir Estate were offered for sale in 1938. They were tucked away behind the main road and within easy reach of Reyrolle, rapidly becoming the town's main employer. Smart semi-villas like these in Lambley Crescent could be purchased from builders J. M. Black for £435 or bought on mortgage for 14*s* 8*d* per week.

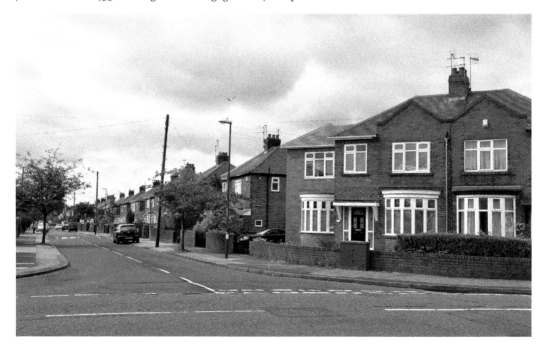

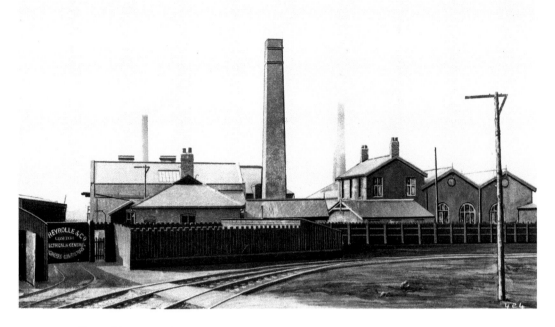

Reyrolle, Hebburn Works, *c.* 1910

Alphonse Reyrolle opened his Hebburn factory in May 1901. After establishing a reputation for high-quality engineering in London, the Frenchman began manufacturing electrical equipment in an unused dyeworks near the railway station. With a workforce of around fifty – a number of them from London – Reyrolle responded to a nationwide demand for electrical power and laid the foundation for a business that is connected to Hebburn to this day. The Colour Works site where Reyrolle began is now a housing estate.

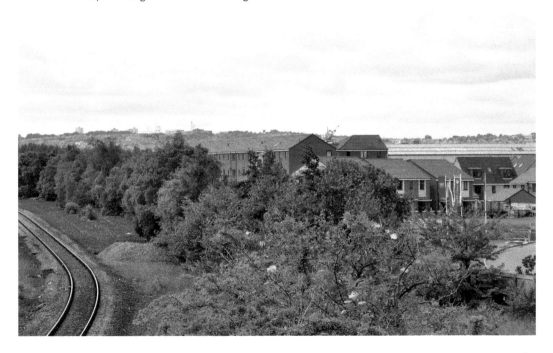

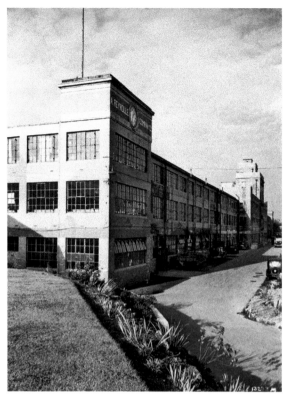

Reyrolle, Newtown Works, *c.* 1950
Despite the death of its founder in 1919, the company carried out his plans for expansion. Land was purchased further west of the original factory and an impressive range of buildings were erected from 1922. The distinctive Newtown Works – known locally as the 'top end' – housed fabrication and machine shops and offices, and until demolished for residential development in the late 1980s it was the familiar face of Hebburn Reyrolle's.

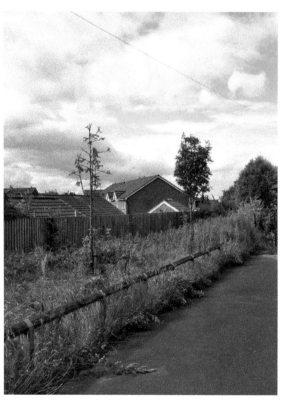

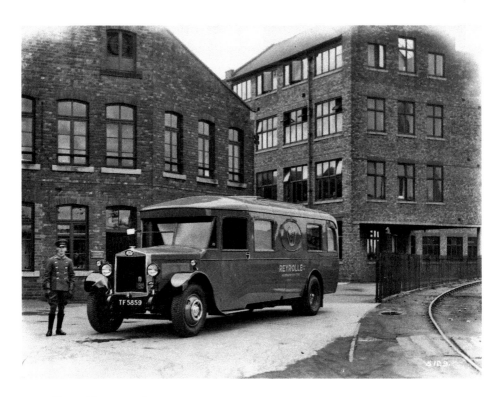

Reyrolle, Hebburn Works, 1931

Reyrolle was becoming a market leader for switchgear and its workforce grew to over 1,000 in the 1920s. It acquired the Newcastle firm of J. H. Holmes in 1928 and began to manufacture electric motors on the Newtown site. Holmes' also developed traffic control equipment, which the Leyland van above was customised to demonstrate. A uniformed Harry Clarke stands beside the 38-hp vehicle, parked outside the main entrance to the works 'bottom end' – now a Persimmon show house.

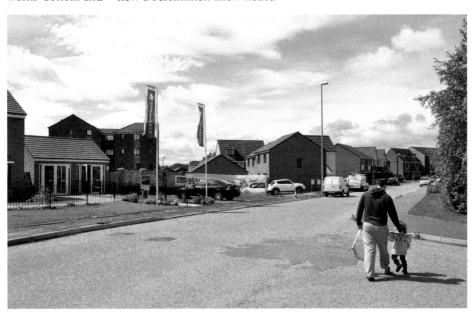

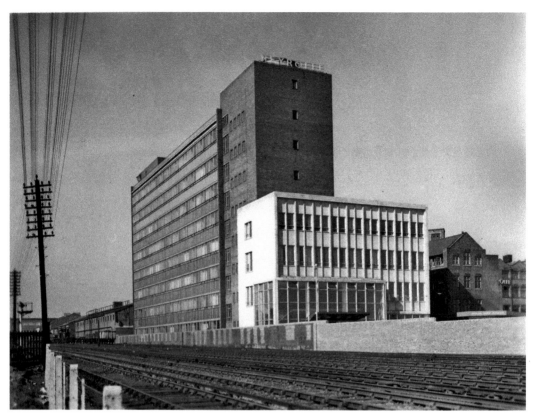

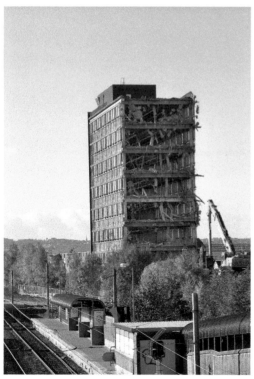

Reyrolle Office Block, 1962 and 2010
Reyrolle's new HQ was built in 1959 at the height of the company's success. It dwarfed the adjacent old buildings, had high-speed lifts and a water- and fireproof basement. Reyrolle was then an internationally renowned manufacturer of switchgear and associated equipment with a workforce of over 10,000, but cutbacks began in 1969 as the company joined in Britain's general industrial decline. Sold to the DHSS a few years later, the Reyrolle offices finally disappeared from the Hebburn skyline in 2010.

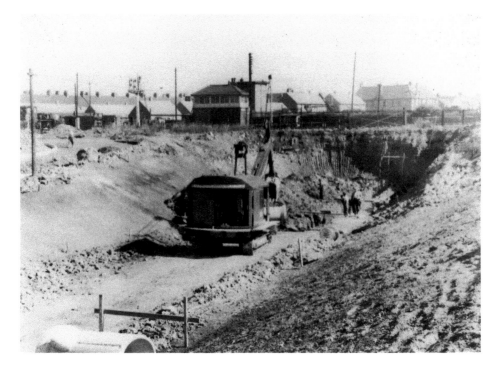

Reyrolle, North Farm Road, *c.* 1955

Factory traffic between Reyrolle's Newtown and Hebburn Works was regularly delayed at the railway crossing off North Farm Road. Construction of a bridge and underpass was necessary to prevent this. It also helped the building of the nearby light engineering factory, opened in 1957, and a laboratory research block that was completed two years later. Westmorland and Durham Courts now dominate the background, and the Newtown Social Club (visible top right in the '50s image) now lies derelict.

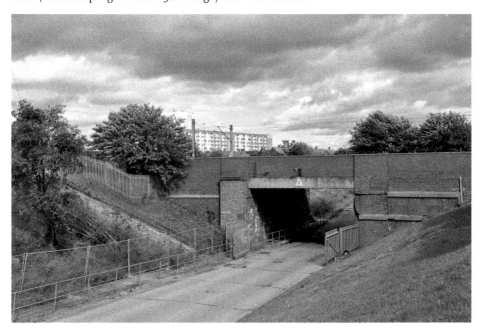

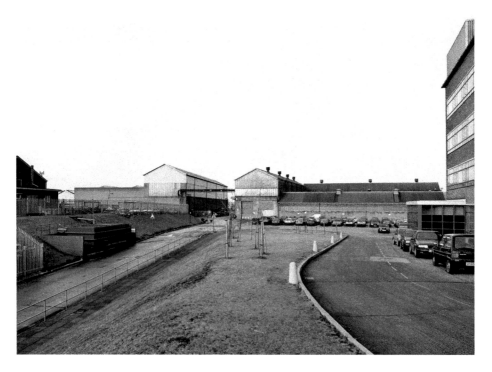

Reyrolle, c. 1998

Reyrolle's continued to shrink after the disposal of the Newtown Works. Around the time of the photograph above, the Hebburn Company had merged with Rolls-Royce and was being purchased by Austrian group VA Tech. It in turn was acquired by German engineering giant Siemens in 2004 and much of area is a now an unfinished building site. Switchgear and relays are still manufactured in the remaining two factories however, and the historic Reyrolle name lives on in their range of products.

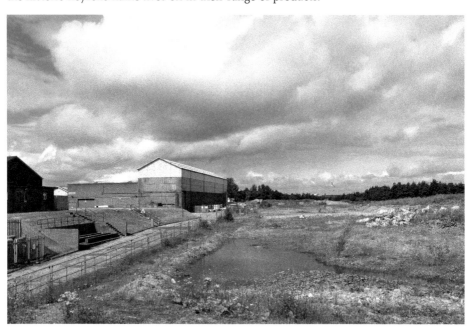

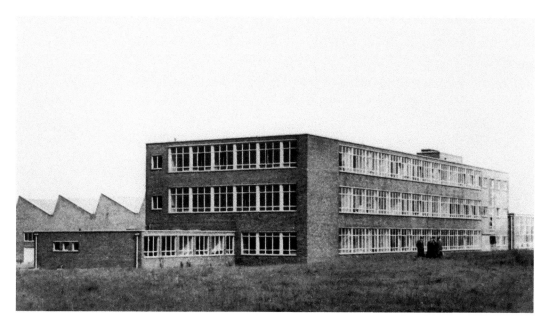

Technical College, Mill Lane, c. 1957

Hebburn Technical College was opened in 1956, providing further education geared mainly to the needs of local industry. Courses in engineering and mining were on offer and many local apprentices learned their basic craft and technical skills in the 'Tech's' classrooms and workshops. The college amalgamated with South Tyneside College in 1984, but has recently fallen victim to education cutbacks and is now earmarked for demolition. It was built opposite a former reservoir on what was known as Waterworks Road.

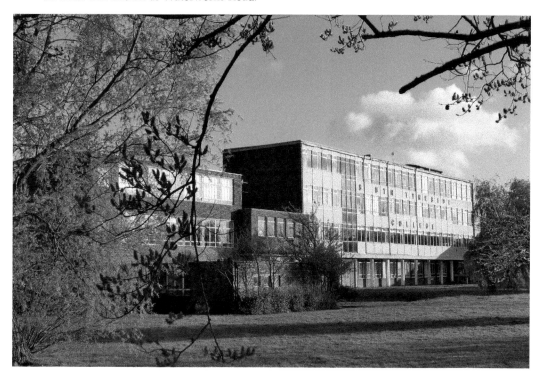

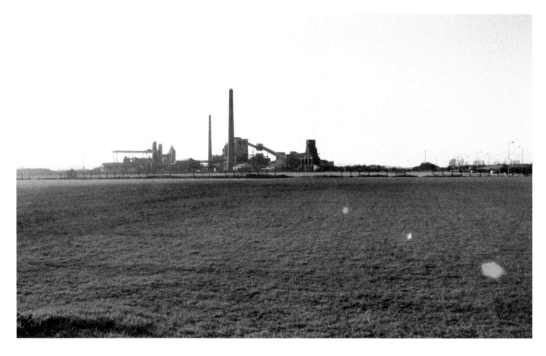

Cokeworks, c. 1990

Built on farmland straddling the Hebburn and Jarrow boundary, the cokeworks began operating in 1936. Initially welcomed at a time of widespread unemployment, the works became an environmental black spot for the houses built near it. Closed in 1990, the site was transformed into a nature reserve and business park but the coke ovens and their dense smoke plumes have not been forgotten. Artist William Pym's sculpture at the former works entrance is reminiscent of a blackened works chimney.

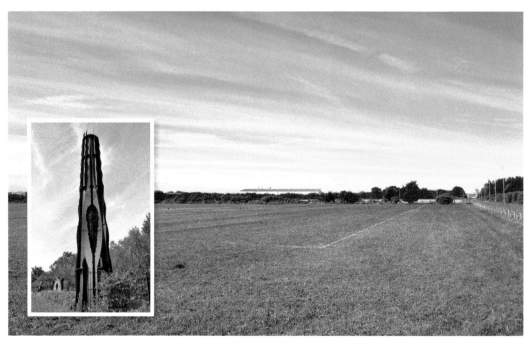

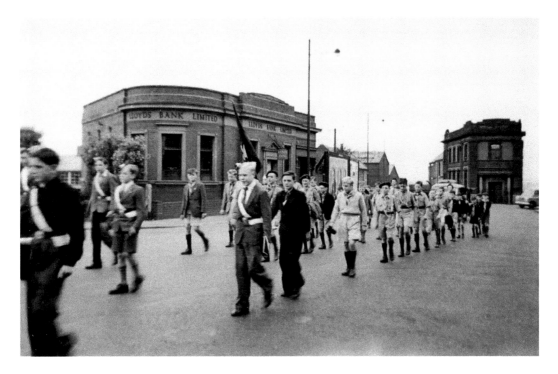

Scout Parade, Prince Consort Road, c. 1955

The 1950s were said to be halcyon days for Hebburn's boy scouts. Here a troop marches briskly past Lloyds bank towards the town centre. The stylish Art Deco building was regrettably flattened in 1998, but Martin's bank on the right (later Barclays bank), built around 1900, survives as a funeral parlour. In the background is the less elegant White's factory, established by marine engineer William White in 1918. It was demolished in 1995 and replaced by White's Gardens housing estate.

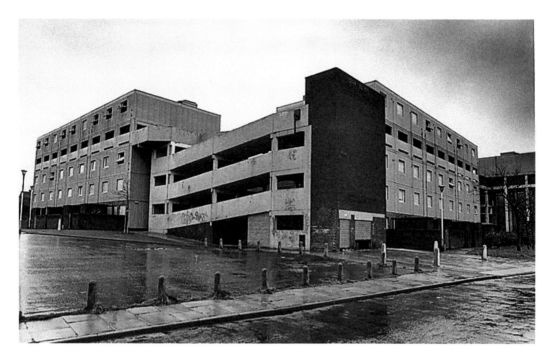

School Street Flats, c. 1989

The School Street scheme failed to solve Hebburn's post-war housing shortage. The ambitious five-year plan was set to transform disused land between the old colliery and the quay. Building began in 1966, spreading out from the School Street site. Although initially well received, the flats were costly to maintain and their brutalist architecture became increasingly unpopular. They were flattened after hardly more than twenty years. Traditional terraced-style houses are now gradually taking their place.

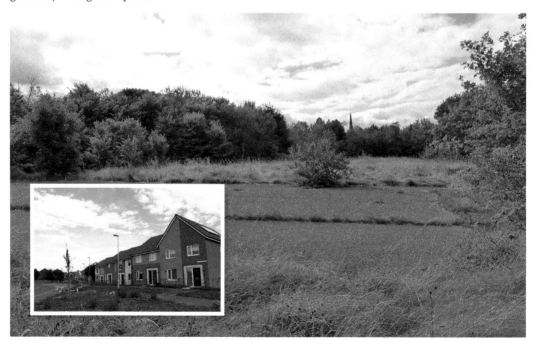

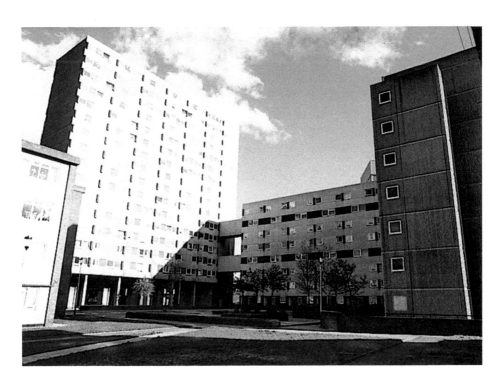

Northumberland and Cumberland Courts, 1991

Northumberland and Cumberland Courts were at the centre of the Newtown's redevelopment
in the 1970s. Along with Durham and Westmorland Courts, they were built to rehouse
residents from the surrounding clearance area. After suffering the social (and structural)
problems of similar tower block estates however, Cumberland Court was demolished in
1992, followed by Northumberland Court seven years later. Durham and Westmorland
Courts remain, interiors renovated and their original bland concrete exteriors given a more
attractive appearance.

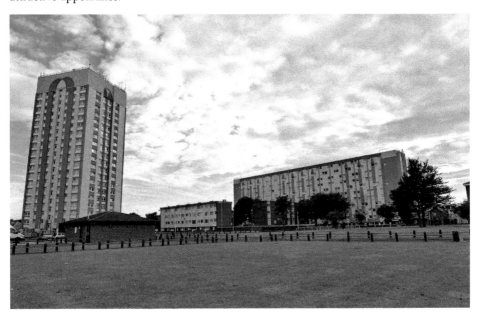

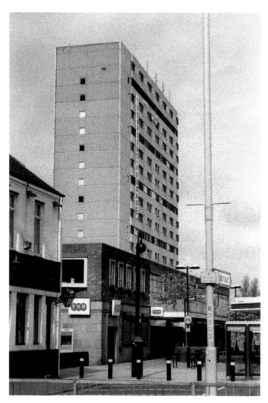

Northumberland Court, 1999
Photographs taken seconds apart capture the final moments of Northumberland Court in March 1999. Demolition company Thompsons of Prudhoe stripped away much of the interior before controlled explosions brought the huge structure crashing down. A dust cloud obscured the shopping precinct as a major part of Hebburn's 1960s town plan collapsed in a pile of rubble.

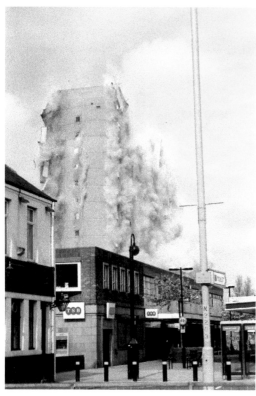

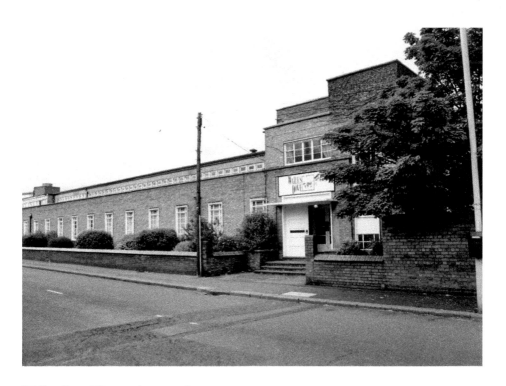

Wailes Dove Bitumastic, c. 1998

Wailes Dove Bitumastic was one of Hebburn's first industries. It started in the town in 1854, capitalising on the ready availability of raw materials for its coal-tar-based products. Over the years the Bitumastic name became a byword for waterproof and anti-corrosive paints, but by 1990 their Hebburn factory was surplus to requirements and it closed in 1999. Bitumastic's impressive offices are seen here before demolition in 2003, as factories again gave way to new homes in Hebburn.

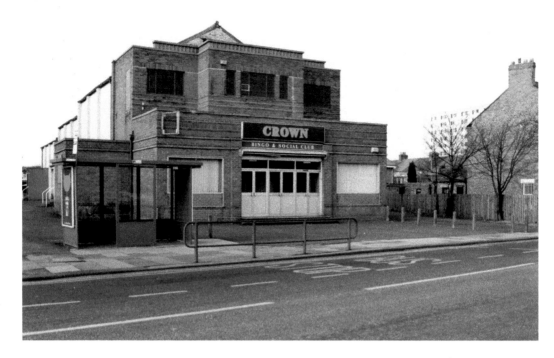

Crown Bingo Hall, *c.* 1994

Pictured here shortly after closure in 1992, the Crown Bingo & Social Club began life as the Rex cinema in 1955. Built for the Dawes brothers, the new cinema was popular for feature films and children's matinees, but followed the national trend and switched to bingo in 1970. Then owned by the Noble Organisation, the Crown continued until the last 'eyes down' and was demolished in 1995. Willowdene Care Home now stands on the site.

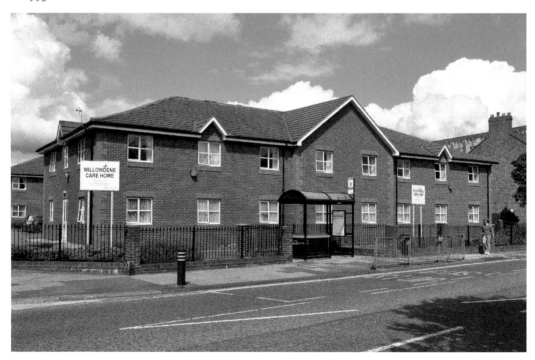

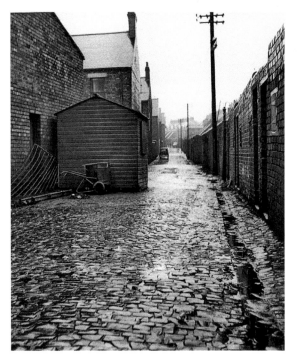

Victoria Road East, Back Lane, c. 1962
This atmospheric photograph
captures a typical Tyneside scene.
Rain-soaked cobbles behind Victoria
Road stretch past the gable ends of
Northborne Road, Collingwood, Howe
and Frobisher Streets. Half a century
on, many of the old terraced houses
remain. Fitted with modern kitchen
and bathroom extensions, they have
outlasted several much newer housing
developments in Hebburn.

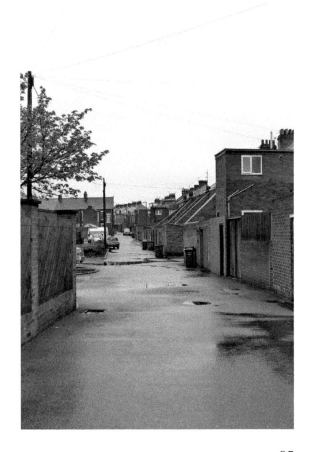

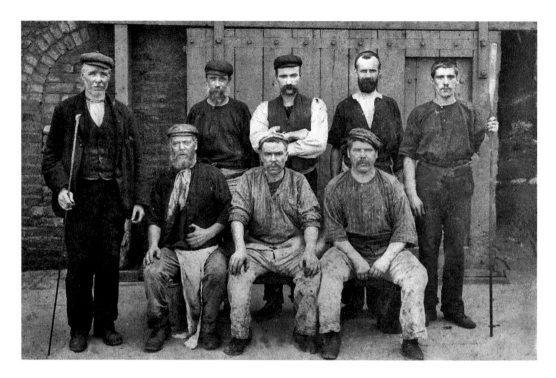

Tharsis Workers, *c.* 1900

Workmen from the Tharsis Sulphur & Copper Company display rakes and ladles that were the tools of their trade. Named after Spanish mines that supplied ore to the works, Tharsis began in Hebburn around 1869, producing over 5,000 tons of copper annually as well as sulphuric acid and iron residue. Comparatively little manufacturing now remains in the town, but craftspeople like these pictured below at Siemens factory – close to the original Tharsis site – keep Hebburn's industrial skills alive.

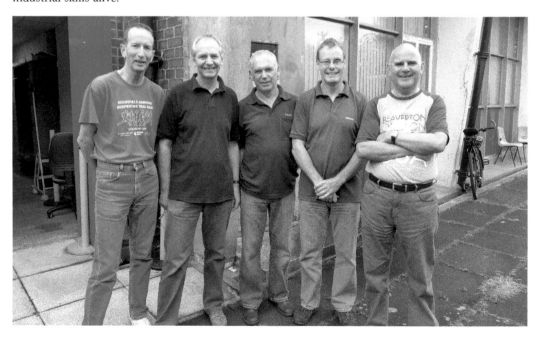